SAVANNAH'S
HISTORIC CHURCHES

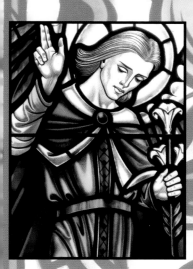
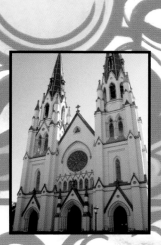
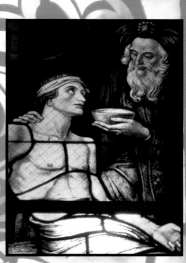

Roy Heizer

Photography by Nancy Heizer

4880 Lower Valley Road, Atglen, Pennsylvania 19310

DEDICATION

This book is dedicated to all of the churches and Synagogues in Savannah. Thank you to each individual house of worship for being a source of information and inspiration!

Schiffer Books are available at special discounts for bulk purchases for sales promotions or premiums. Special editions, including personalized covers, corporate imprints, and excerpts can be created in large quantities for special needs. For more information contact the publisher:

Published by Schiffer Publishing Ltd.
4880 Lower Valley Road
Atglen, PA 19310
Phone: (610) 593-1777; Fax: (610) 593-2002
E-mail: Info@schifferbooks.com

For the largest selection of fine reference books on this and related subjects,
please visit our website at: **www.schifferbooks.com**
We are always looking for people to write books on new and related subjects.
If you have an idea for a book, please contact us at **proposals@schifferbooks.com**

This book may be purchased from the publisher.
Include $5.00 for shipping.
Please try your bookstore first.
You may write for a free catalog.

In Europe, Schiffer books are distributed by
Bushwood Books
6 Marksbury Ave.
Kew Gardens
Surrey TW9 4JF England
Phone: 44 (0) 20 8392 8585; Fax: 44 (0) 20 8392 9876
E-mail: info@bushwoodbooks.co.uk
Website: www.bushwoodbooks.co.uk

Other Schiffer Books by the Author:
Savannah's Garden Plants, 978-0-7643-3265-4, $16.99
Atlanta's Garden Plants, 978-0-7643-3810-6, $14.99

Other Schiffer Books on Related Subjects:
Savannah Squares: A Keepsake Tour of Gardens, Architecture, and Monuments, 0-7643-2047-5, $9.95
Civil War Walking Tour of Savannah, 0-7643-2537-X, $19.95

Copyright © 2011 by Roy Heizer
Unless otherwise noted, all images are the property of the author.
Library of Congress Control Number: 2011933602

Designed by Mark David Bowyer
Type set in Trajan Pro / Garamond

ISBN: 978-0-7643-3864-9
Printed in China

CONTENTS

Introduction .. 4
 Sources .. 4
Agudath Achim .. 5
Ardsley Park Baptist Church .. 9
Asbury Memorial United Methodist Church...................... 11
Asbury United Methodist Church 16
Bethlehem Baptist Church.. 18
Bnai Brith Jacob ... 20
Bull Street Baptist Church .. 25
Cathedral of St. John the Baptist....................................... 26
Christ Church .. 32
Episcopal Church of St. Paul the Apostle 36
First African Baptist Church .. 51
First Baptist Church... 55
First Bryan Baptist Church... 58
First Christian Church.. 61
First Church of Christ, Scientist... 62
First Congregational Church.. 63
First Presbyterian Church .. 66
Independent Presbyterian Church..................................... 73
Isle of Hope United Methodist Church.............................. 76
Lutheran Church of the Ascension 79
Mickve Israel .. 84
Quaker Society of Friends.. 88
Sacred Heart Catholic Church .. 89
Second African Baptist Church ... 93
St. Benedict the Moor Catholic Church 97
St. John's Episcopal Church .. 100
St. Paul's Evangelical Lutheran Church............................. 105
St. Paul's Greek Orthodox Church 108
St. Philip African Methodist Episcopal 112
Trinity United Methodist Church...................................... 114
Wesley Monumental United Methodist Church................. 120
Wesley Oak United Methodist Church............................... 125
White Bluff Presbyterian Church....................................... 126

INTRODUCTION

Welcome to Savannah, Georgia! Explore the history of Savannah's oldest churches and their congregations, and learn the fun and engaging stories about the fascinating architecture, dedicated leaders, and diverse congregations. There are stories of setbacks and tales of progress. Grand historical perspectives are blended with celebrity filled trivia and fun facts. *Savannah's Historic Churches* is not a book about theology, but rather a collected view of Savannah's congregational heritage. All of the Churches and Synagogues that are included have had a continuous congregation for at least one hundred years and are still in existence today. With over 130 full-color digital photographs, appreciate both interior and exterior views of the facades, architectural details, and stained glass windows. The stories of hope and determination told here are pillars of each individual congregation.

SOURCES

The stories recounted here are from a multitude of sources: historic markers, cornerstones, websites, church plaques, recollections of church leaders and members, church pamphlets, local news stories, anecdotes from tour guides, and the author's own personal observations.

A special thank you to each house of worship and their members for the knowledge they shared.

AGUDATH ACHIM

9 Lee Boulevard

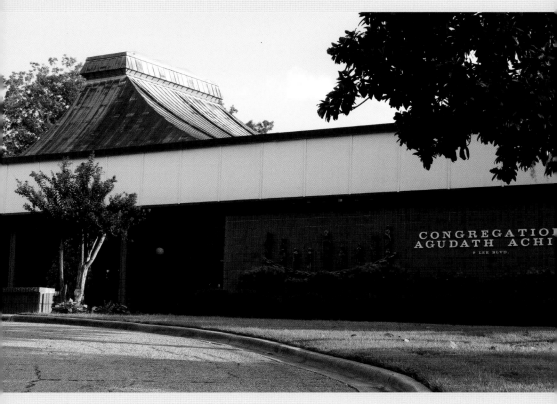

Congregation Agudath Achim.

A petition for incorporation as a religious society was granted to "Congregation Agoodath Ahhim" December 7, 1902. In the early years the congregation held services in rented space, not having a permanent building. Published accounts state that the congregation's first building was on Bryan St. and later on Congress Street.

The Congregation purchased its first building in 1919, located on Montgomery and York Streets, and that building was just large enough to house one hundred

people, including the balcony. The first full-time Cantor came to Agoodath Ahhim in 1927 at an annual salary of $1,000. By 1936, the Congregation had outgrown the York Street building and the topic of the construction of a new and larger edifice began. Initial membership dues were set at $12 per year, but were elevated to $25 in 1923. Additional funds were raised by fining elected officers 50 cents for failure to attend weekly meetings.

A location was found on Drayton Street and the cornerstone for the new Synagogue was laid in September 1940. Inside the cornerstone was a copper time capsule. The time capsule contained a letter from President Franklin D. Roosevelt, congregational minutes, newspaper clippings that were current at that time, and a copy of the constitution of the congregation Bnai Brith Jacob. This building was open to the Congregation for the first time in June, 1941. This was the congregation's building for the next thirty years. The original congregation was entirely Orthodox, and it was not until 1945 when Agoodath Ahhim joined the United Synagogue of America that it became the first Conservative (a denominational connotation, not a political implication) congregation in Georgia. Shortly thereafter in 1950, when its original charter was renewed, the congregation's name was officially changed to Agudath Achim.

In 1968, a new synagogue was to be erected. The building committee selected architect Leon J. Meyer. Formal ground-breaking ceremonies were held in November 1970 on Lee Boulevard. The property was donated by J. Curtis Lewis in honor of Sam Steinberg. The cornerstone of the Drayton Street Synagogue was moved during the building of the new synagogue. It was incorporated into the new Lee Boulevard Synagogue. The copper time capsule was opened and new items relating to the history of the Congregation were placed inside. The official dedication of the new building on Lee Boulevard commenced on September 19, 1971. Agudath Achim is the southernmost Synagogue in Savannah. Lee Boulevard runs between Abercorn and White Bluff, not far from Bnai Brith Jacob. Agudath Achim, along with Mickve Israel, also hosts the Shalom School.

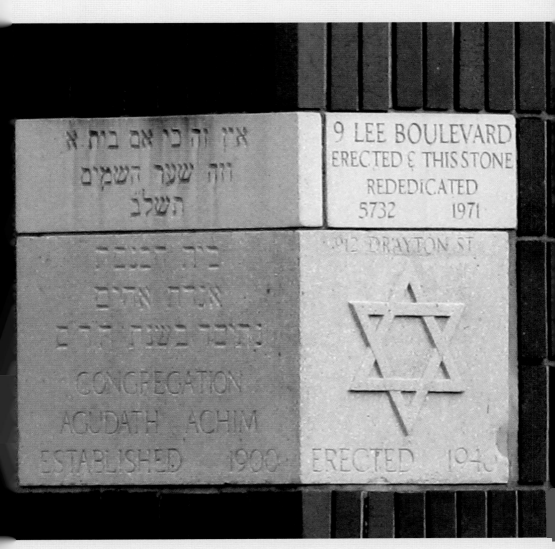

The cornerstone of the Synagogue of Agudath Achim.

The front entrance at Agudath Achim resembles a menorah.

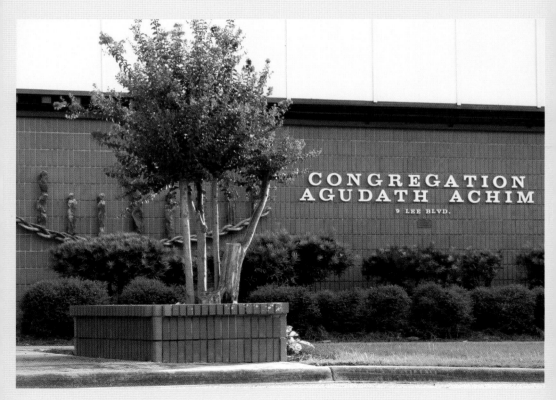

Congregation Agudath Achim.

Ardsley Park Baptist Church

1 East 55th Street

In 1905, the neighborhood of Ardsley Park was just beginning to develop. It was the first ring of suburbs, in what Savannians now call Mid-town. Ardsley Park stretches from roughly Bull Street to Waters Avenue. As the suburbs grew, those communities developed a need for churches.

The west side of Ardsley Park had, by the year 1908, grown large enough that its residents established a Baptist congregation, one of Savannah's first neighborhood churches. Ardsley Park continued to grow and develop and, in just over fifty years, it had grown large enough that the Baptist congregation built its current church building. This classic brick Greek Revival church faces west along Bull Street south of Victory Drive.

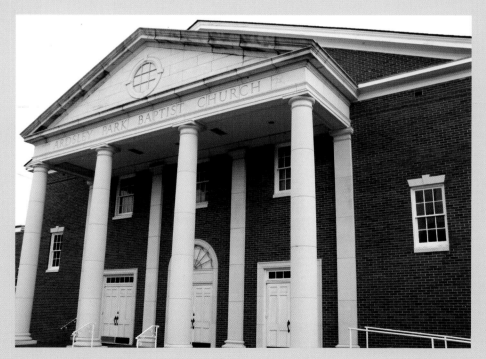

Ardsley Park Baptist Church.

Window at Ardsley Park Baptist Church.

ASBURY MEMORIAL
UNITED
METHODIST CHURCH

1008 Henry Street

Asbury Memorial United Methodist Church was established in 1909. The cornerstone of the present building at the intersection of Henry and Waters was laid in 1921. The education building was added thirty-three years later to accommodate the growing congregation. Through the 1950s and 60s the congregation at Asbury Memorial continued to grow and thrive.

Asbury Memorial United Methodist Church.

During the 1970s and into the 1980s, the church's congregation began to dwindle. As membership declined, the building fell into disrepair and outreach programs were cut. By 1990 the congregation had only twenty-five members and the United Methodist Church was seriously considering closing the doors at Asbury Memorial.

In 1993, Asbury Memorial had a transformation. A small group of women decided to meet for fellowship and to try one last fund-raiser to see if they could save their church. This group named themselves The Busy Bees and they began to sew clown dolls and sell them. At first, the sale of the clown dolls only paid the bills, but as the popularity of the dolls grew they saved the church from closure. Asbury Memorial's membership began to grow again and by the turn of the new century it was once again a fledgling congregation. The church adopted the clown as its logo, to remind the members what it was like in difficult times and that tenacity and a sense of humor leads to success.

Asbury Memorial starts its services at what many consider to be an odd time, 11:15. The reason for this time is attributed to the current minister, Reverend Billy Hester. During the difficult years of the 1980s, Asbury Memorial could only afford a part time minister. Wesley Oak United Methodist Church across town could also only afford a part time minister. The United Methodist Church split

Views of Asbury Memorial United Methodist Church

Stain glass window.

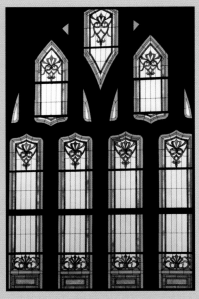

Stained glass window in back of the altar.

the Reverend Hester between the two congregations, one starting early and one later. Reverend Hester would conduct services at Wesley Oak early and then drive to Asbury Memorial to conduct a second service later. When both churches could again afford a full time minister, Asbury Memorial became Reverend Hester's only church. The later time schedule stayed the same.

Asbury Memorial United Methodist Church has become famous in Savannah for its theatre productions. For several years, in autumn, the church has held Broadway themed services that are wildly popular. Broadway musical themes are a regular part of services at Asbury Memorial. Since the addition of the clown and the Broadway themes, the atmosphere at Asbury Memorial is dedicated, lighthearted and fun. The church is inclusive and the diversity of the congregation is held as one of its strongest traditions.

In 2008, the congregation at Asbury Memorial raised funds for, and implemented, a $1 million-dollar renovation project. The outdated sanctuary was refurbished with new paint, flooring, chairs and lighting. A new and expanded alter area was also installed. The educational building also received new flooring and paint. The exterior was cleaned and new landscaping was installed. A newly renovated building leads this thriving congregation into a promising future.

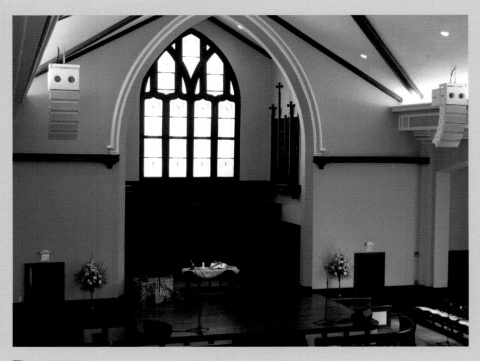

The sanctuary.

Chancel.

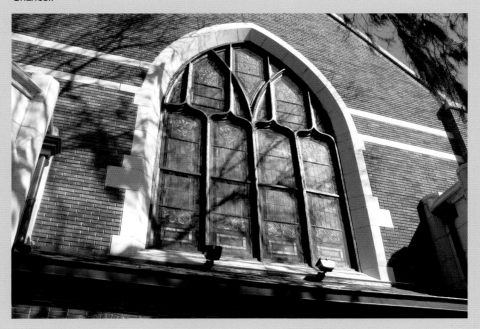

Window detail.

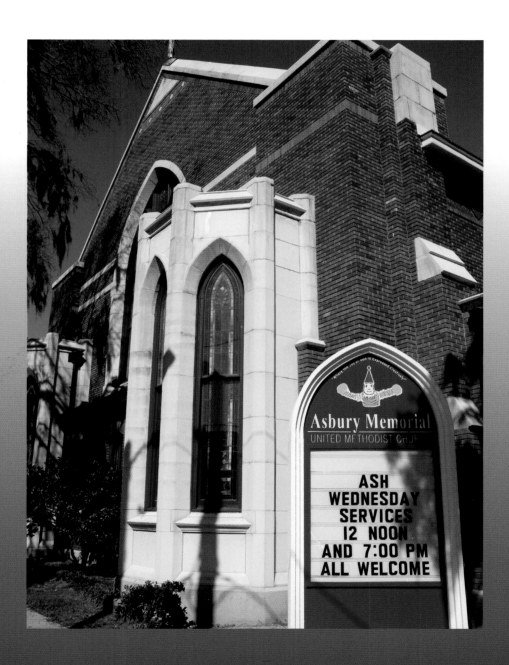

ASBURY UNITED METHODIST CHURCH

1201 Abercorn Street

I n 1871, a newly formed congregation of black Methodists purchased Andrew Chapel and named it Francis Asbury. This early incarnation was led by the Reverend Charles O. Fisher. In the summer of 1871, the local newspaper reported the formal transfer of the church to the "colored" congregation of the Methodist Church of America. In 1927, the church moved to its present location. Throughout its 135-year history, several ministers have led the Asbury congregation.

Savannah's first black Boy Scout troop was organized by S. L. White in the basement of Asbury United Methodist Church in the mid-1900s. Today, many community services and programs continue the tradition at Asbury United Methodist Church.

This church, housed in a large building along Abercorn Street, is a redbrick structure highlighted with white window and door frames. Asbury United Methodist Church has a traditional Victorian architectural style.

Asbury United
Methodist Church.

BETHLEHEM BAPTIST CHURCH

1008 May Street

The congregation of Bethlehem Baptist Church was founded February 2, 1859. The congregation grew during the years of the Civil War. In 1871 the congregation built its first church building.

By the early to mid-1900s, the building needed repairing and was reconstructed in the 1940s. The current Bethlehem Baptist Church building located on May Street was dedicated on December 15, 1946. The building is constructed of handmade bricks and features a single steeple on the southeast corner. In the second half of the 1900s a social hall and classroom space were added to accommodate the growing congregation.

Bethlehem Baptist Church is located near the historic Laurel Grove Cemetery. The church is currently led by the Reverend Wilson Scott.

Bethlehem Baptist Church.

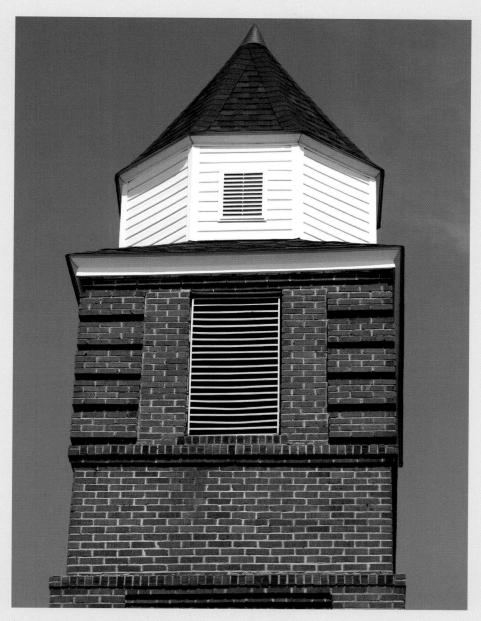

Steeple detail, Bethlehem Baptist.

BNAI BRITH JACOB

5444 Abercorn Street

Congregation B. B. Jacob owes its beginnings to the Jewish immigrants from Poland and Russia who were of the Ashkenazi tradition. This was in contrast to the Sephardic tradition that was practiced at Congregation Mickve Israel, Savannah's oldest Jewish community. Due to the differences in traditions, Congregation B. B. Jacob was organized by Rabbi Jacob Rosenfeld in 1861. By 1866, the membership had increased and a frame building was erected on the northeast corner of State and Montgomery Streets.

As the number of Jewish immigrants began to increase, a new building was planned to serve the needs of a growing congregation. Over the years, hand written journals have been found documenting meetings in April of 1891.

In 1907, plans to complete a new Synagogue at the same site were developed by the B. B. Jacob Building Committee. Although there were no funds available to build, they were able to raise 20,000 dollars from sales and donations. In the year 1909, a beautiful new red brick edifice was constructed at the cost of 45,000 dollars. The building was notable for its Moorish style domes on the west facing corners and for its arabesque patterned windows. The building was designed by Architect Hyman Witcover, who also designed the Scottish Rite building on Madison Square.

In 1913, Rabbi Charles Blumenthal was installed as Rabbi. Under the leadership of Rabbi Blumenthal, the Hebrew School enrolled two hundred children, an all time enrollment record. Several other leaders of B.B. Jacob have included Rabbi Nathan Rosen and Rabbi William Drazin.

B'nos Chesed Shel Emes was organized in 1916 to provide last rites to women, and that organization built the Chapel at Bonaventure Cemetery. The Daughters of B. B. Jacob, the forerunner of the modern day Sisterhood, was formed in 1921 as a social group.

The history of B. B. Jacob continued to evolve when, in 1945, Rabbi A. I. Rosenberg began to inspire congregants about a new Synagogue. To quote Rabbi Rosenberg, "There was a great deal of tradition and warmth that we enjoyed for over a century in the old location of our Synagogue and it is our obligation to retain those traditions in our new edifice." The new Synagogue, on Abercorn Street, was completed in 1962. A Synagogue is a House of Prayer, a House of Study, and a House of gathering. The three separate sections of this building express these same three functions.

Furnished to serve as a youth area, the large entrance hall on the south side of the building represents the spirit of the congregation. As a symbol of the past and the future, the wall of memory is presented in this area. Also located in the entrance hall is the original 95-year-old lintel stone, inscribed with the name of the first congregation and the date when the old Synagogue was built. The cornerstone of the building, which was used from 1909 to 1962, has also been embedded in this wall, together with all the plaques recording various donations of sacred objects and pews from the old building. The new Chapel was furnished from the old Synagogue with the Bimah, the Torah Ark, the Eternal Light, and the benches. The old chandeliers were installed in the new Social Hall. The 1962 Synagogue also features a large mural in the sanctuary that depicts scenes from the Jewish tradition. The exterior of the building is white brick and can be seen from Abercorn Street just south of the DeRenne Parkway. The old Synagogue at State and Montgomery streets still stands and is used today as a Savannah College of Art and Design (SCAD) building.

Today B. B. Jacob's commitment to tradition continues with the leadership of Rabbi Avigdor Slatus, who has served since 1981. Congregation B. B. Jacob is also involved in the Jewish Educational Alliance, a community center that is open to the public for community activities throughout the year.

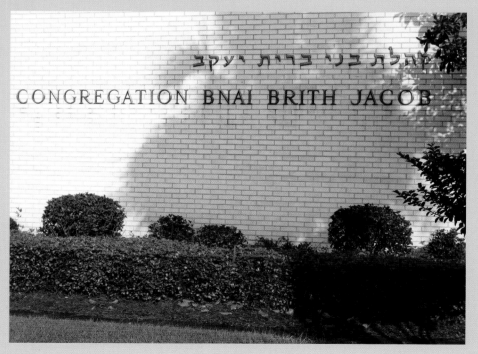

Bnai Brith Jacob.

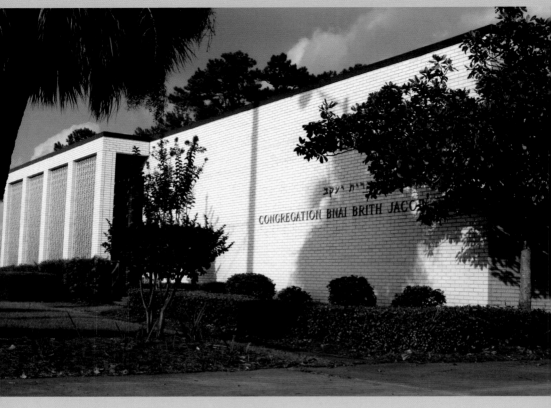

The synagogue for Congregation Bnai Brith Jacob.

The garden at Bnai Brith.

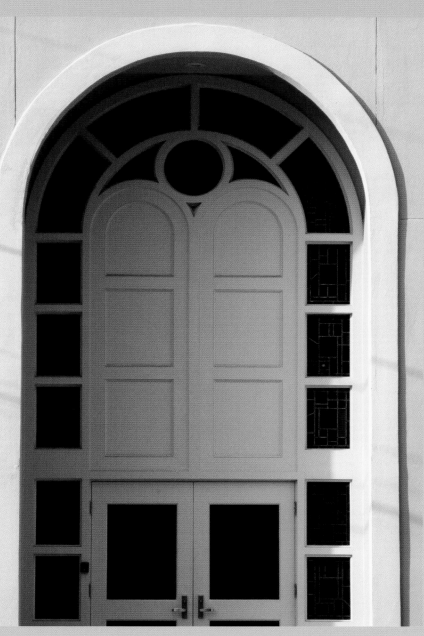

Entrance way to the Rabbi Abraham I. Rosenberg Educational Building.

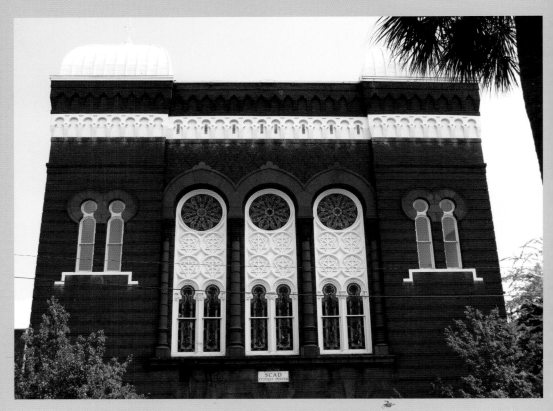

The former BBJ synagogue on Montgomery Street is now a SCAD Student Center. This building is a fine example of Moorish style architecture.

BULL STREET
BAPTIST CHURCH

17 East Anderson Street

B ull Street Baptist Church was founded April 15, 1891. It was originally a mission church of First Baptist Church on Chippewa Square. Large Greek Revival columns dominate the facade of the church.

Bull Street Baptist Church is a participant in the Tri-Church festival, held each year since 1956, with St. Paul's Greek Orthodox Church and St. Paul's Evangelical Lutheran Church. The three Churches are in close proximity on Bull Street, just south of Forsyth Park.

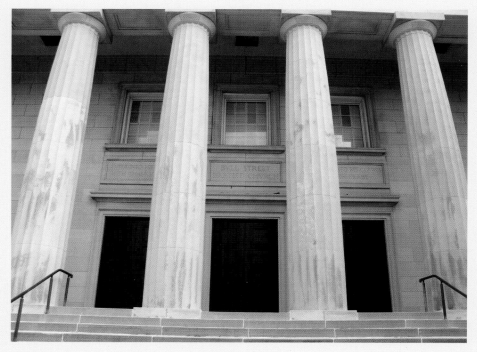

Entrance to Bull Street Baptist Church, a classic
example of a Greek Revival structure.

CATHEDRAL OF
ST. JOHN THE BAPTIST

222 East Harris Street

J ames Edward Oglethorpe, the founder of Savannah, and the trustees originally banned Catholics in the colony of Georgia. The Catholic prohibition was not due to religious prejudice, but to the conflicts with Spanish occupied Florida. The trustees thought that Catholics would be sympathetic to the Spaniards. The Spaniards were, at the time, the political enemies of the British. Once the Spaniards relinquished Florida, Catholics were allowed in Savannah.

The first Catholic parish to be established in Savannah, the congregation de Saint Jean-Baptiste, was organized at the end of the eighteenth century. To accommodate an increasing Catholic congregation, half a trust lot on Liberty Square was reserved as a place for the small frame church of Saint John the Baptist. By August 1811, city officials granted a petition for a parcel of land at Montgomery and Hull Streets. The congregation eventually settled on a site at Drayton and Perry Streets.

In 1835, the cornerstone of the new church was laid by Bishop John England. Four years later, in April 1839, Bishop England dedicated the 1,000-seat Church of St. John the Baptist. Fifteen years later the Church of St. John the Baptist needed repairs following a hurricane. The name was also changed to Cathedral in 1850.

By 1870, a new Cathedral building was being planned. Abercorn Street at LaFayette Square was chosen as a location and land was procured. On November 19, 1873, the cornerstone of the new Cathedral was laid. The new Cathedral was named Our Lady of Perpetual Help.

On April 30, 1876, the new French Gothic style Cathedral was dedicated. The Cathedral was large and ornate. The original 1876 baptismal font is still in use today and is located at the rear of the center aisle, just inside the sanctuary doors. The four side altars were made of Italian marble. The steeples contained sixteen gargoyles.

By the end of the 1800s, the twin spires had been added and the entire structure was covered in Stucco. Not long after the 207-foot-tall spires were installed, a fire gutted the Cathedral. Rebuilding began immediately and was completed in December 1899. Over the next several years, Christopher Murphy, a local artist, designed and created the murals. The Steeple bell was cast in Baltimore, Maryland, in 1900. It weighs 4,730 pounds. The stained glass was created by Innsbruck Glassworks of Austria around 1904. The Lancet windows in the apse are twenty-four feet tall. It took thirteen years for the decoration and interior artwork of the Cathedral to be completed.

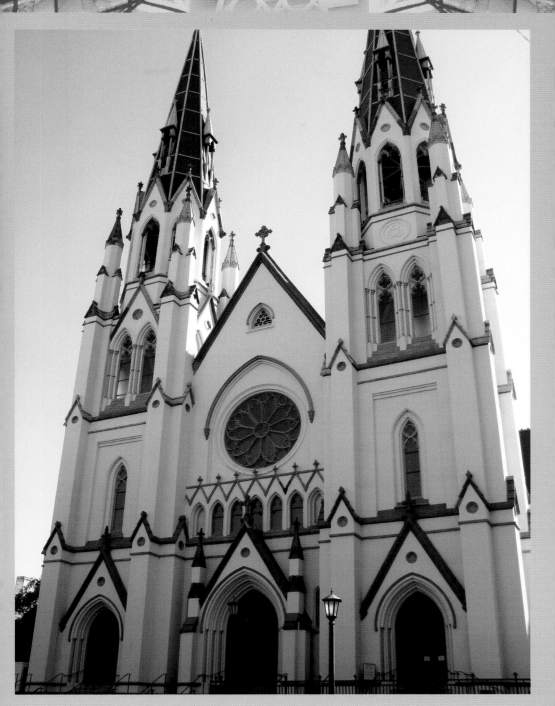

The Cathedral of St. John the Baptist.

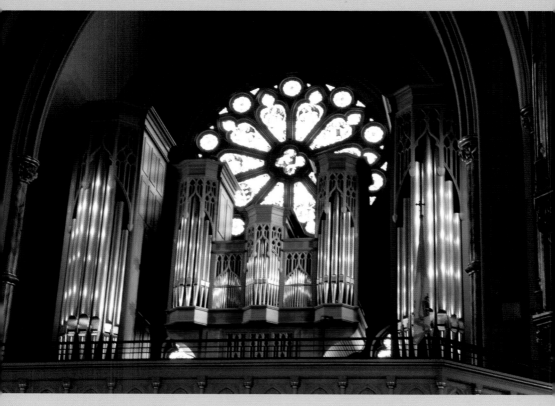

Noak organ in the sanctuary.

The Rose window located directly over the organ is a Gothic medallion. It has a quatrefoil at its center. St. Cecilia, the patroness of Music, is in the center piece. The quatrefoil and the trefoil design repeat several times across the architecture of the sanctuary. The newly restored Cathedral was consecrated in 1920. Several minor renovations and updates occurred between the 1920s and 80s.

In September 1998, a major restoration for the Cathedral of St. John the Baptist was begun. The slate roof was replaced and other significant works were completed over the next two years. The Noack organ, created in Georgetown, Massachusetts, was installed in 1987. The organ features over 2,300 pipes. The year 2000 was the 100th anniversary of the rededication of the Cathedral. Today, the sanctuary is open to the public for quiet self guided tours.

Views of the Cathedral of St. John the Baptist

The garden.

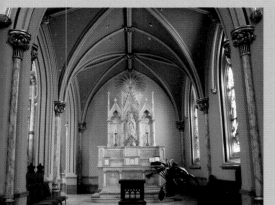 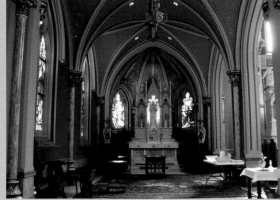

Side chapels.

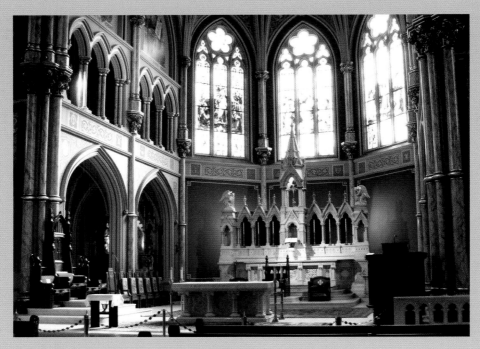

The apse at the Cathedral of St. John the Baptist.

Cathedral of St. John the Baptist.

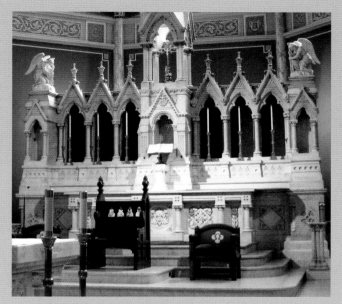

Close-up of the Chancel.

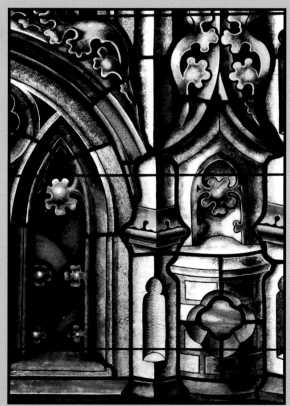

Stain glass window.

Christ Church

18 Bull Street

The colony of Savannah was founded in February 1733. It was in the same year that James Edward Oglethorpe, the founder of Savannah, designated the east trust lot on Johnson Square for Christ Church. In those years the church had no name or building, and services were conducted in a small wooden building that was used as the colony's courthouse.

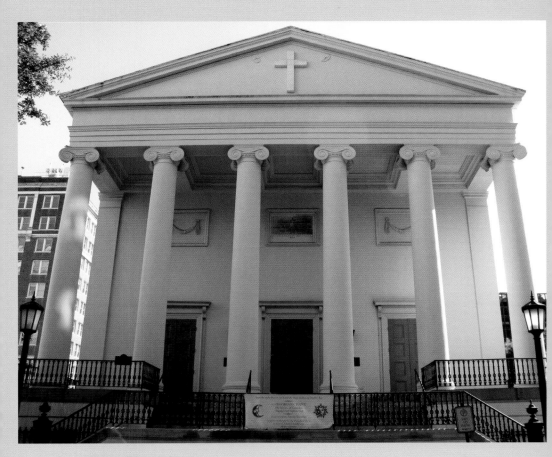

Christ Church Episcopal.

It was at the courthouse location that the two most well-known rectors preached. John Wesley was the third rector to lead the church, serving from 1736-1737. John Wesley returned to England after only a few years in Savannah. Upon his return to England he founded the modern Methodist denomination along with his brother Charles.

George Whitefield was the fourth rector to lead Christ Church, serving from 1738-1740. George Whitefield traveled during his tenure at Christ Church, raising money for an orphanage in Savannah. The name of this orphanage is Bethesda, and it is still in operation today. Bethesda has the honor of being the oldest continuously operating orphanage in America.

The original building on the current site was destroyed by fire in 1796. A second building was built on the same site in 1803. The second structure was brought down by a hurricane in 1804. The current building was designed by architect James Hamilton Couper and built in 1838, but was severely damaged by fire in 1897. The reconstructed sanctuary is still in use today.

The large stained glass window in the pulpit area is thought to be an authentic Tiffany window. The stained glass window is almost thirty feet high and over ten feet wide.

Christ Church today is proudly called "The Mother Church of Georgia," as it is the oldest continuously serving church in Georgia. Christ Church also hosts the annual Tour of Homes and Gardens in March, a tradition in Savannah for over seventy-five years.

The bells at Christ Church await the Hand Bell Choir.

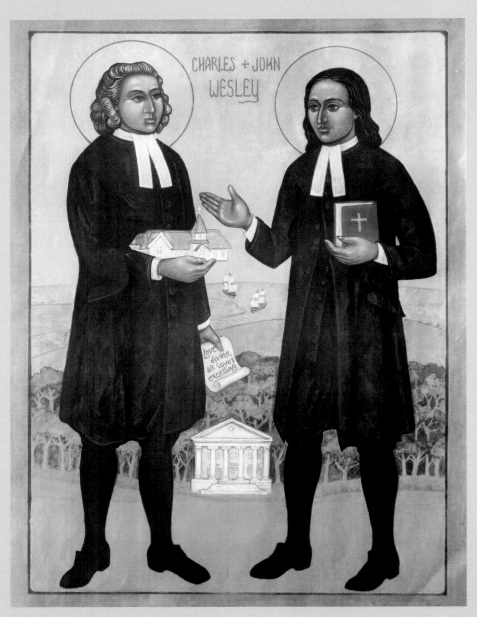

Charles and John Wesley.

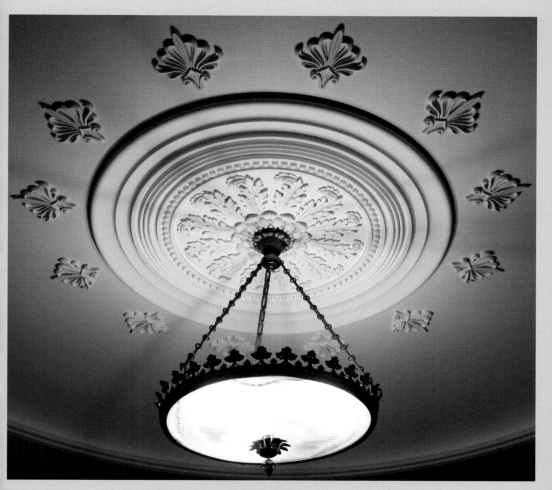

Light fixture detail in the chapel, Christ Church.

Episcopal Church of St. Paul the Apostle

1802 Abercorn Street

The Episcopal Church of St. Paul the Apostle was erected in 1907. The cornerstone was laid on January 25 and its first service was held on November 17. The church can trace its origins back to 1852 along with the creation of the City Mission.

The Mission proved so successful that by 1857 $15,000 had been raised to build a church on Calhoun Square. It served as the home of St. Paul's until it was closed in December 1864 by the Rev. Dr. John Easter, who fled with the retreating Confederate troops to South Carolina as General Sherman's army was seizing Savannah. St. Paul's building served as a military hospital during the waning days of the Civil War.

In 1866, the church was destroyed by fire. Accounts of the event are contradictory. One report said the fire happened when "some boys celebrating Christmas in our noisy Savannah way" were less than careful. Another account claimed the fire was deliberately set. Whatever the cause, the result was the same: the church was burned to the ground and the parishioners were without a place for services. The loss of the church forced what remained of the parish back upon the care of St. John's Episcopal.

At the turn-of-the-twentieth century, Mrs. Eliza Lewis Clinch made a bequest of property to St. Paul's. Mrs. Clinch's gift was worth $40,000 and the leaders of St. Paul's decided the land would be sold to finance a new structure. The building at Duffy and Barnard Streets was sold to the Greek Orthodox Community. Those two property sales provided the funds to purchase the parcel at Abercorn and 34th Streets for the new home of St. Paul's Church.

Chicago architect John Sutcliffe designed the new St. Paul's edifice. He modeled his plans on the English Gothic style of the fourteenth century, specifying brick instead of the stone usually used in English churches. With its red Augusta brick exterior, St. Paul's blended well with the neighborhood. The interior walls are Birmingham red brick and the stained trusses and timbers of the roof are native Georgia pine. The carved wood furnishings are from Wisconsin. The reredos, pews, chancel rail, rood screen, pulpit, and statues were all crafted by trained workmen. The west window was designed by Mayer Studios of Munich, Germany. The interior of St. Paul's has a distinct and unique character.

In 1927, the construction of the parish house was completed, but tragedy hit twice that year. First, a roof truss fell and killed the foreman. Later, Pattie McGlohon, the youngest daughter of Fr. and Mrs. McGlohon, died.

Rev. Canon Theodore P. Ball became rector in 1948. One example of Fr. Ball's commitment to St. Paul's happened in January 1959. A fire broke out in the parish house and Fr. Ball broke through a window and saved church items from destruction. He was, during the incident, recovering from surgery. He re-injured himself fighting the fire and needed another operation.

Fr. Peacock, who served St. Paul's next, is responsible for the majority of the stained glass windows in the church building. The beautiful windows, produced in England, depict scenes from the Christian tradition.

In 1975, Curtis Lewis donated his mother's house at 224 East 34th Street to St. Paul's and it was decided by the church's congregation to renovate the property to serve as the Rectory.

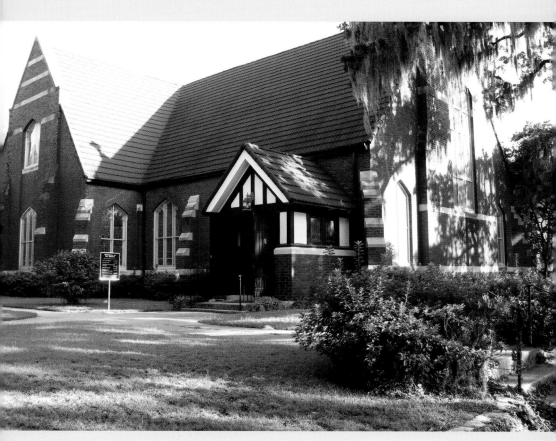

Episcopal Church of St. Paul the Apostle.

The Rev. Ronald W. Forsyth became the Rector of St. Paul's in 1982. Fr. Forsyth completed the stained glass window project begun under Fr. Peacock, which encompassed the installation of the windows in the chancel, as well as the windows in the upper transepts. Fr. Forsyth died unexpectedly in 1986.

With the arrival of Rev. William Willoughby III as Rector in 1987, the work St. Paul's had begun with Habitat for Humanity and the Second Harvest Food Bank continued to expand. In 1989, Bishop Shipps appointed Fr. Willoughby Dean of Savannah. St. Paul's saw increasing diversity within the church and continued to reach out to its neighbors.

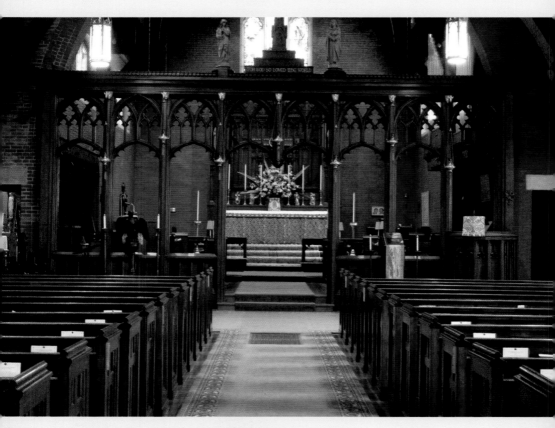

Sanctuary, Episcopal Church of St. Paul the Apostle.

A mystery developed when, in 1993, a stained glass window of St. Paul's was uncovered behind the reredos in the Chapel. Research revealed that it had been the central panel of the East Window above the Altar of the church building at Duffy and Barnard Streets. It was learned that there had been dissension about its inclusion in the new St. Paul's, so it had simply been bricked over. The window, after being in the chapel wall for eighty-six years, is now on display behind the baptismal font in a light box beneath the great West Window.

St. Paul's magnificent Fratelli Ruffatti/Rodgers organ was rebuilt in 1996. In addition to the restoration of the existing ranks, a new console and choir division were added. All agree the sound quality is extraordinary.

In preparation for the 100th anniversary of the current church building, a campaign was launched in 2005 to improve and conserve the material legacy of St. Paul's. The church building received a new steel roof. The church's magnificent stained glass has been restored. A bookstore and gift shop were added. A major goal of the campaign was to make all facilities accessible and with the addition of a wheelchair ramp and an elevator, this goal was achieved.

The Parish of St. Paul the Apostle took the entire year of 2007 to celebrate the 100-year anniversary of the present building. The Centennial Year schedule included events, lectures and concerts.

In 2010, St. Paul's started the installation of an art gallery that will be available to the public. The history of St. Paul's continues to be written.

Views of Episcopal Church of St. Paul the Apostle

Stained glass window found behind reredos.

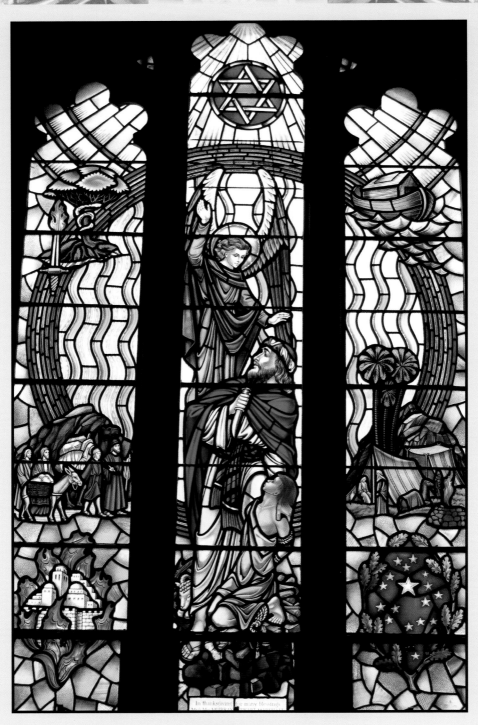

These are just some of St. Paul's beautiful stained glass windows.

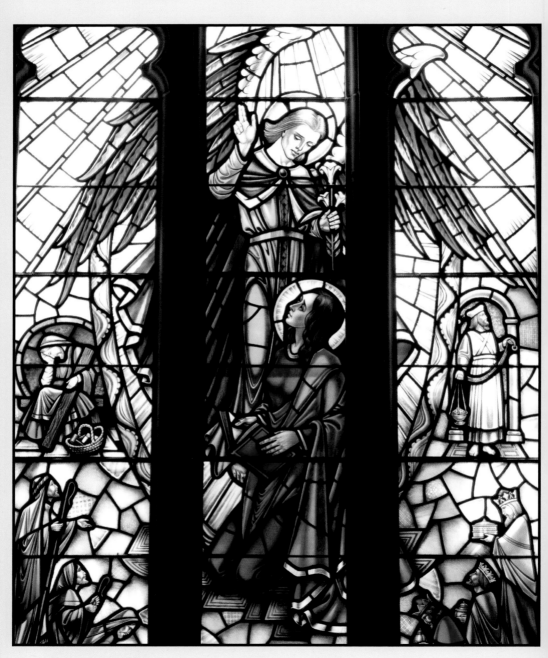

Stained glass window.

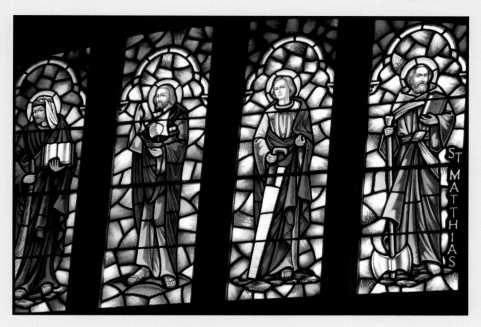

Stained glass of biblical figures in chancel area.

Bells outside
the church.

Stain glass window details.

Stain glass window details.

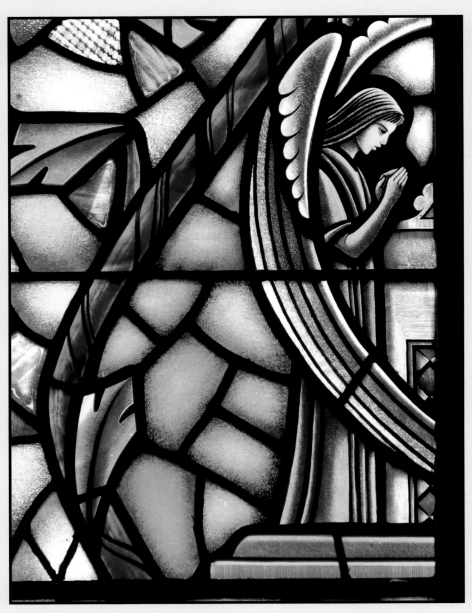

Stain glass window details.

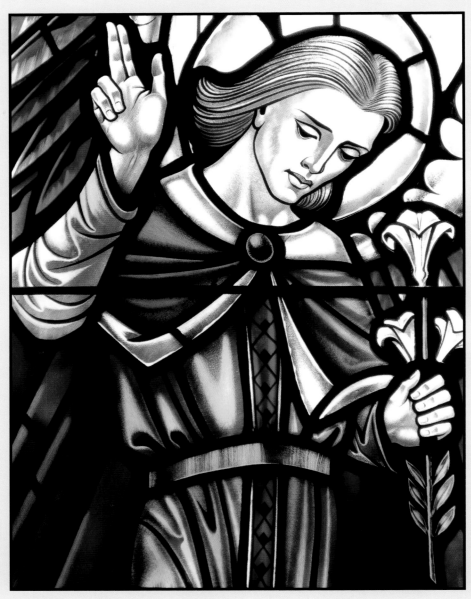

Stain glass window details.

FIRST AFRICAN BAPTIST CHURCH

23 Montgomery Street

First African Baptist Church is now located on the northwest trust lot of Franklin Square. The current church building was dedicated in 1861, but the congregational history reaches back to 1773. In the early 1770s, while still a slave, George Leile was licensed by the Baptists to preach in the thirteenth colony of Georgia and in South Carolina. Leile preached along the Savannah River, eventually becoming a founding member of Silver Bluff Baptist Church in South Carolina. At the start of the Revolutionary War, Leile went to Savannah due to the British's offer to secure the freedom of slaves who had escaped their rebel masters. Near Savannah, in 1782, George Leile converted several families, including Andrew Bryan and his wife Hannah.

In the mid-1780s, the British moved hundreds of blacks from Savannah, many of them went to Nova Scotia, London, and other places. Another Baptist preacher in the area, David George, went to Nova Scotia. David George started a Canadian congregation. George Leile and his family went to Jamaica, and later migrated to Sierra Leone. Andrew Bryan was the only one of these early Baptist preachers to stay in Savannah.

The congregation that would become known as First African Baptist was organized near Savannah by Andrew Bryan. Bryan's first church was organized in 1788 with nearly one hundred members. In 1794, the congregation moved closer to Savannah and built a church on West Bryan Street. This new church was called First Colored Baptist Church. First Colored Baptist quickly grew and by the early 1800s the membership was at seven hundred. The First Colored Baptist Church congregation renamed itself First African Baptist Church in 1822.

Andrew C. Marshall, Andrew Bryan's nephew, became the senior pastor of First African Baptist in 1815 and led the congregation for many years. In the 1830s, the congregation split over doctrinal issues and Andrew C. Marshall, along with over 2,500 members left and moved the congregation one last time, this time to Franklin Square. There they bought a church building that had housed white Baptists. The remaining church on West Bryan Street first became known as Third African Baptist Church and later as First Bryan Baptist Church.

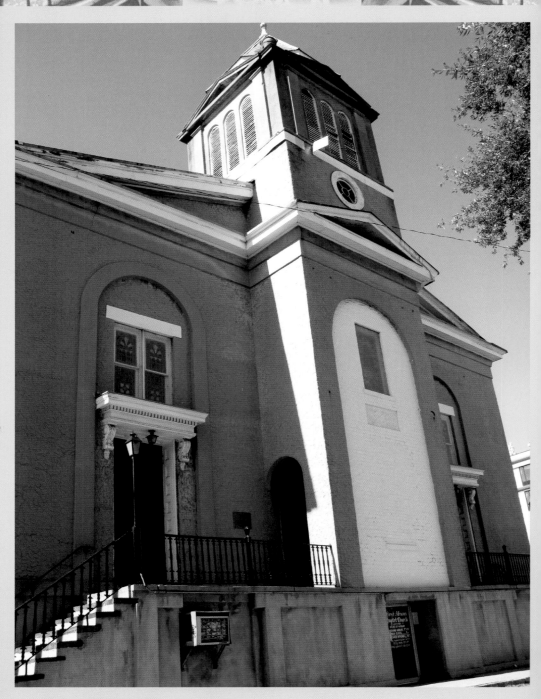

First African Baptist Church.

The current First African Baptist Church building, which still stands on Franklin Square today, was constructed between 1859 and 1861. The building is made of Savannah Grey brick and these bricks were hand made by the congregants themselves. During the years of the American Civil War, First African Baptist Church continued to play a vital role in the history of America. First African Baptist was a part of the Underground Railroad, a system of places and people that helped slaves escape to freedom. The ground floor of the building exhibits holes drilled into the wooden floor. These hand drilled holes were meant to look like tribal patterns, but in fact gave escaping slaves air to breath while hiding under the floorboards. The patterned holes were also used to give slaves directions about where to go, through underground tunnels that led to the river and on to waiting ships. First African Baptist's participation in the Underground Railroad helped perhaps hundreds of slaves secure their freedom. The church still has many of the original pews, some of which contain tribal symbols, hand carved by slaves during the Civil War years.

Just after the Civil War, in the 1870s, the original three-story church steeple was damaged beyond repair and the current smaller steeple was built. The sanctuary has a large pulpit area. Over the pulpit are magnificent stained glass windows that depict portraits of the founders and early ministers of the church.

During the Civil Rights era of the 1960s, First African Baptist served as an important place for Civil Rights participants. The church provided a meeting place as well as a place of inspiration. A display of the sanctuary and a narration of the movement can be found at the Ralph Mark Gilbert Civil Rights Museum on Martin Luther King, Jr. Boulevard. The Ralph Mark Gilbert Civil Rights Museum is named in honor of the Rev. Ralph Mark Gilbert, the senior minister at First African Baptist from 1939 to 1956.

In recent years First African Baptist has had many well-known speakers, most notable among them was Coretta Scott King, the widow of Dr. Martin Luther King, Jr. The church also held the memorial service for Dr. Martha Fay; a local teacher, biogeneticist, and Civil rights participant.

In the summer of 2009, John Mellencamp, a legendary American singer, recorded three songs in the sanctuary of First African Baptist Church. These three songs were recorded using old fashioned recording techniques and a single microphone. The songs that John Mellencamp recorded at First African Baptist were released in August 2010 on the album "No Better Than This" (Rounder Records). A documentary of the recording sessions at First African Baptist was filmed to coincide with Mellencamp's subsequent album tour.

Recently, First African Baptist Church was featured on a national cable news network. This feature story gave the church national exposure and told some of the history of the church and congregation. The church is currently planning a restoration project so it can continue to serve Savannah into the future.

First African Baptist Church is open to the public for tours. A knowledgeable guide will show visitors the historic sanctuary, the oldest pulpit in Savannah, the fellowship hall and the museum. The museum contains photos, books, letters and artifacts related to the history of America's oldest black church.

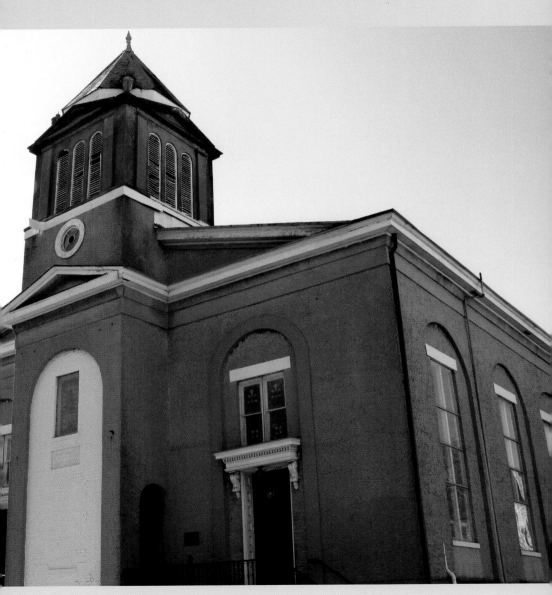

Side view, First African Baptist.

FIRST BAPTIST CHURCH

223 Bull Street

First Baptist Church was chartered November 26, 1800. The original church was built on Franklin Square. The church was granted a perpetual charter December 19, 1801, by Governor Josiah Tattnall, Jr. On February 2, 1831, the cornerstone was installed at the current church on Chippewa Square. The new building was designed by architect Elias Carter and was completed in 1833. The name has been the First Baptist Church since February 4, 1847. First Baptist Church is Savannah's oldest standing church. The Greek revival style architecture has not significantly changed over the years, but the building has had several remodeling and repair projects completed.

This church was one of a few Southern churches that did not cease operations during the Civil War. Pastor Sylvanus Landrum preached on a Sunday in December 1864 to a congregation of Confederate soldiers. During the following week, Savannah surrendered to the Union forces and General William T. Sherman entered Savannah with his Union troops. The next Sunday Pastor Landrum preached to a congregation of Union soldiers.

First Baptist Church features a large pipe organ, which was made by Ontko & Young of Charleston in 1990. The sanctuary has several large windows with clear glass that run from floor to ceiling. Covering the entire northwest trust lot on Chippewa Square, the church enjoys a large social hall that is used for congregational gatherings.

The 176-year-old sanctuary of First Baptist Church of Savannah recently underwent major repairs. In 2008, a member noticed that a new crack had appeared in the plaster ceiling. An evaluation by a structural engineer revealed issues with the roof trusses. When the sanctuary had been expanded in 1922, heavy materials added extra weight to the roof. Now, eighty-eight years later, the roof was showing stress and needed to be strengthened. The investigation did not reveal an immediate danger for congregants, but it was deemed necessary for a restoration project to begin immediately. The sanctuary was closed for repairs beginning in January 2010 and reopened six weeks later.

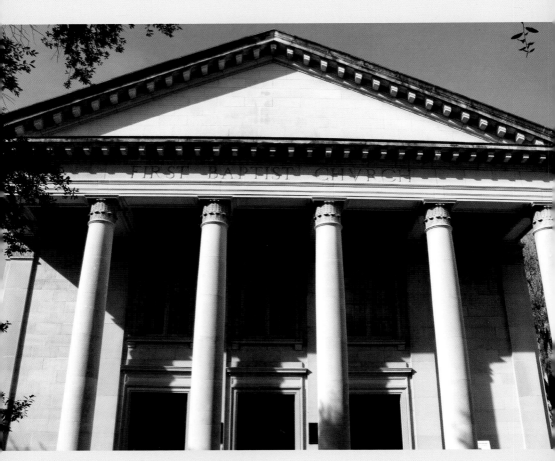

First Baptist Church on Chippewa Square.

Close-up of the Grand Entrance, First Baptist Church.

First Bryan
Baptist Church

575 West Bryan Street

First Colored Baptist Church was organized January 20, 1788. It was led by Reverend Andrew Bryan, who had been baptized by George Leile. The property on which the church now sits was purchased by Reverend Bryan on September 4, 1795, for a sum of $150. It is the oldest continuously owned African American church property in the United States.

In 1822, the church became known as the First African Baptist Church. In 1832, the congregation split over doctrinal issues. The Reverend Andrew Cox Marshall and a large number of congregants left to form another congregation. They took the name First African Baptist Church with them. That church settled on Franklin Square and is still known today as First African Baptist Church. The remaining members continued under the name Third African Baptist Church, remaining at the original location on West Bryan Street.

During the Civil War years, Third African Baptist Church was pastored by Ulysses L. Houston. He was chosen along with several other pastors to attend a meeting with Union General William T. Sherman and Secretary of War Edwin Stanton in the Green-Meldrim House. This meeting led to Sherman issuing Field Order #15, known in American history as The Forty Acres and a Mule Speech.

In April 1867, the church was renamed First Bryan Baptist Church after its founding minister. First Bryan Baptist Church is the oldest continuous black Baptist church in America and is therefore a historical landmark.

First Bryan Baptist Church has supported many groups and organizations over the years. Boy Scout Troop 49 was formed at First Bryan Baptist Church in 1934. Several members of First Bryan Baptist Church were important to the Civil Rights movement in Savannah. The late W. W. Law, a member of First Bryan Baptist Church, was an important Civil Rights figure in Savannah. In 1988, First Bryan Baptist Church celebrated its 200th anniversary. At that time a cornerstone laid in 1873 was opened. Several artifacts from the cornerstone are now on display. First Bryan Baptist Church continues to be a beacon in the religious community of Savannah.

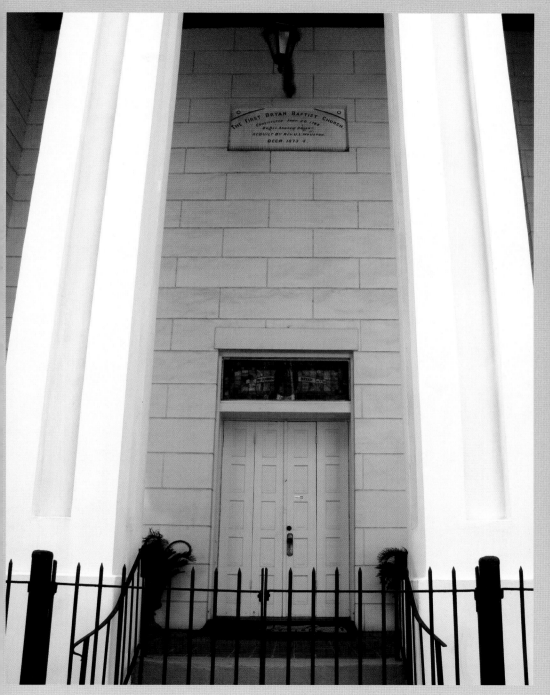

First Bryan Baptist Church.

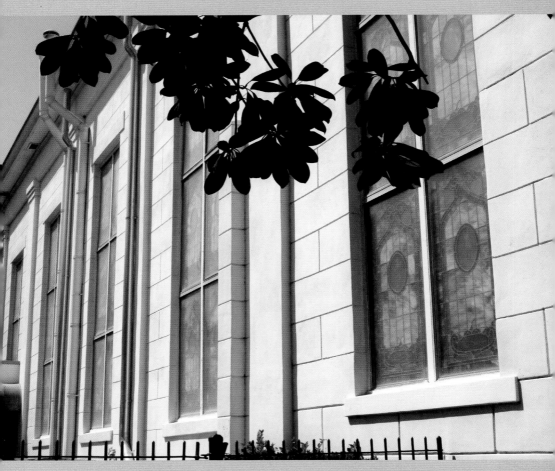

Stained glass windows along the side, First Bryan Baptist Church.

First
Christian Church

711 East Victory Drive

T he congregation of First Christian Church formed in 1819. The cornerstone for the current edifice was laid in 1950. Situated on the edge of Ardsley Park, the building is a classic example of church architecture. The red brick facade rises into the steeple that sits over the vestibule, allowing for the sanctuaries extension on the large parcel.

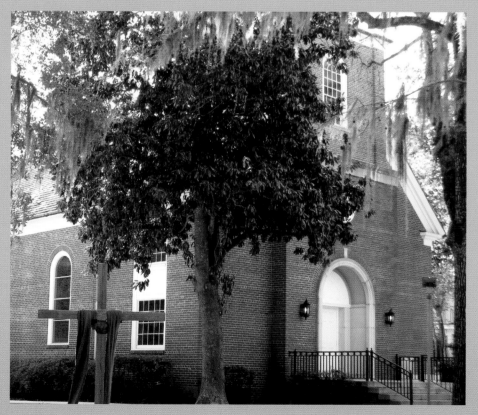

First Christian Church.

FIRST CHURCH OF
CHRIST, SCIENTIST

211 East Victory Drive

T he congregation of the First Church of Christ, Scientist was formed in 1899. The current location on Victory Drive dates from 1957.

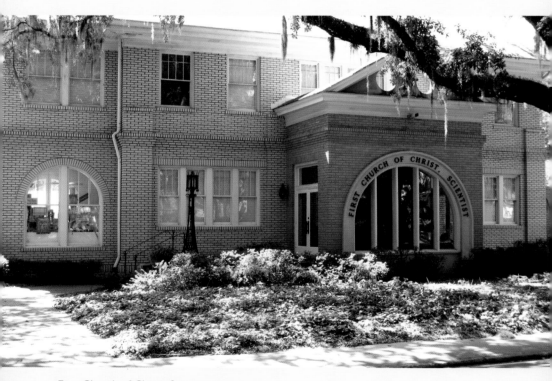

First Church of Christ, Scientist.

FIRST CONGREGATIONAL CHURCH

421 Habersham Street

First Congregational Church was founded in 1869, at the end of the Civil War. At that time many freed slaves who had not been allowed to attend church became regular churchgoers. A need for a black congregation on the edge of the Historic District facilitated the dedication of First Congregational Church, and by 1878, it had grown enough to support the construction of a permanent edifice. A Savannah Grey Brick church was built in that year.

A few years later, in 1894, a fire destroyed the church. The members quickly rebuilt, dedicating the current building in 1895. A beautiful and large stained glass

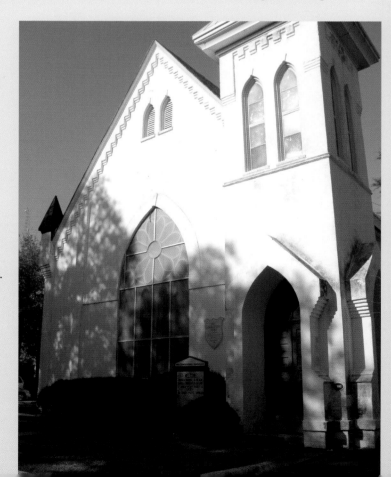

First Congregational Church.

window was later installed. Exterior improvements such as stucco and fencing were added. In 1977, an annex was added on to the church. It was dedicated to Mrs. Madeleine V. Hannar for her years of service to the church. In the Annex is a memorial plaque dedicated to the Reverend Arthur C. Curtright, who served First Congregational Church from 1939 to 1959.

In recent years, First Congregational Church was featured on a television show about church restorations. Savannah College of Art and Design students drew up plans for the churches kitchen and two bathrooms. Members and locals pitched in to help and the results rejuvenated the attendees.

In March 2007, Randall Williams played a concert at First Congregational Church as part of the Savannah Music Festival. In 2010, the First Congregational Church saw refurbishment of the exterior of the building. The project involved replacing old gutters, roof repairs and work on the large stained glass window that graces the front of the church. The church has seen steady attendance over the years, and has been active in both Wesley Ward and the greater community.

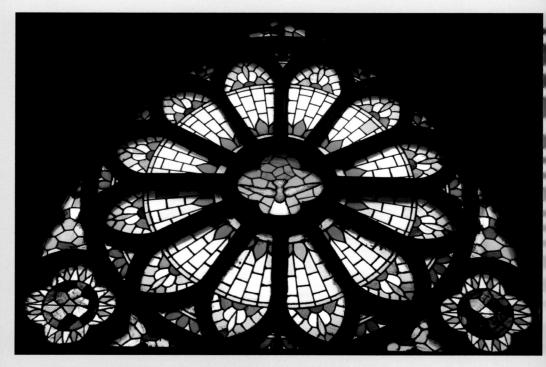

Stained glass window rosette, First Congregational Church.

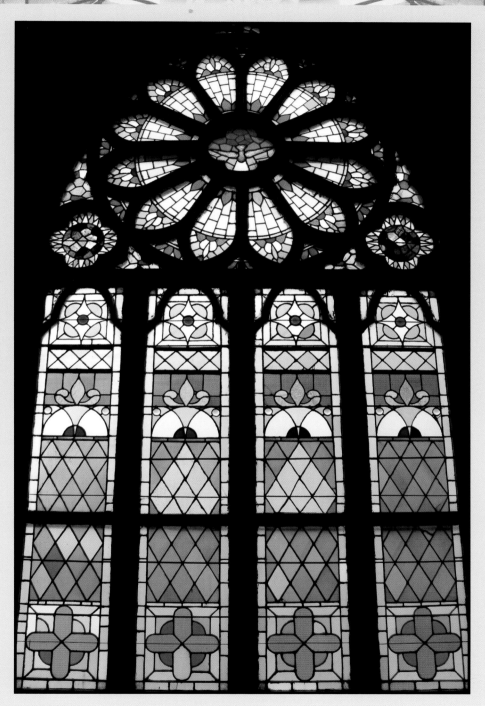

Stained glass window, First Congregational Church.

First Presbyterian Church

520 Washington Avenue

First Presbyterian Church was established in 1827 by thirteen members of the Independent Presbyterian Church of Savannah. The congregation erected its first church building in 1834, on Broughton Street between Barnard and Jefferson streets.

In 1857, a new church structure was started on Monterrey Square. The Civil War delayed its completion until 1872.

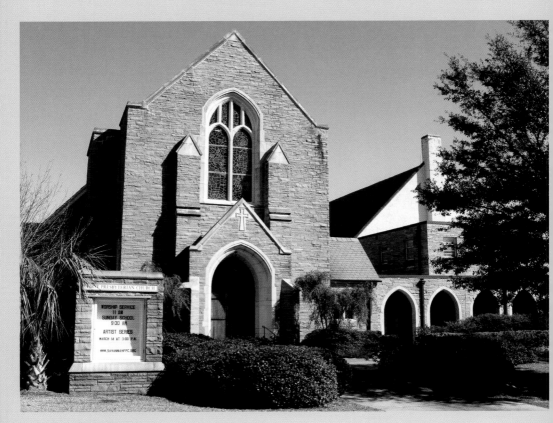

First Presbyterian Church.

In 1956, a new sanctuary was built on Washington Avenue in the developing Ardsley Park neighborhood. Ardsley Park, which dates to about 1905, is a large planned neighborhood south of the Historic District. The new church was designed in a neo-Gothic architectural style that features a repeating lancet pattern in the windows, doorways, and walkway arches. The new church was dedicated in December 1956.

First Presbyterian Church contains several marble plaques that were saved from the Monterrey Square building. The church maintains a beautiful courtyard garden. A Schlueter organ, built in Georgia, was installed in 2007 at a cost of $650,000. First Presbyterian Church features many concerts and lectures in Stewart Hall, a large fellowship hall. The Savannah Folk Music Society holds regular concerts at First Presbyterian.

Recently, country music legend Kenny Rogers stopped by First Presbyterian Church to photograph the sanctuary.

Views of First Presbyterian Church

Sunlit corridor.

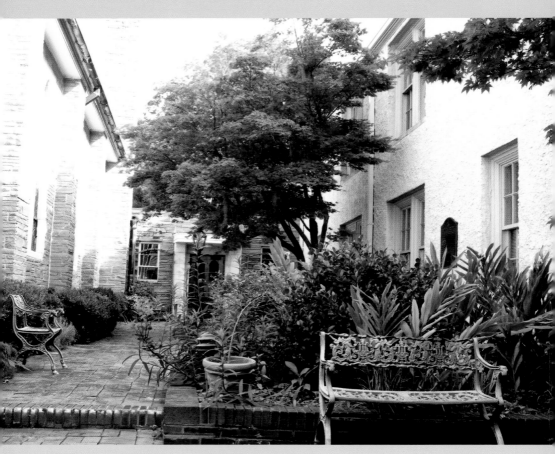

Courtyard garden.

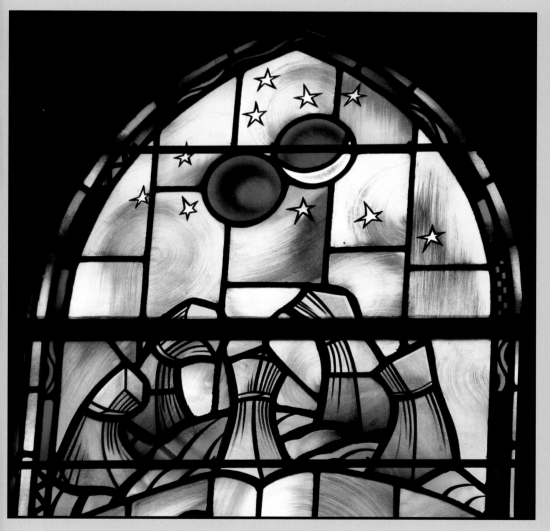

Stain glass window.

Vestibule entrance door.

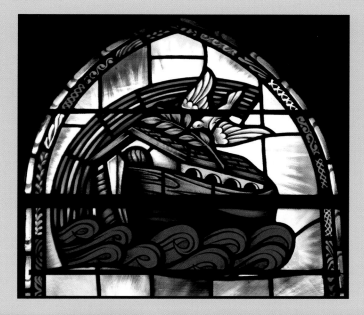

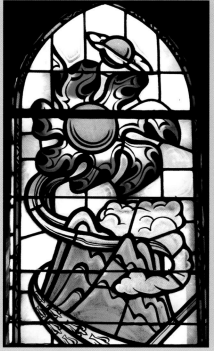

Stain glass window details, First Presbyterian Church.

Stain glass window details, First Presbyterian Church.

INDEPENDENT PRESBYTERIAN CHURCH

207 Bull Street

I ndependent Presbyterian Church dates to 1755. The original building faced Ellis Square, and the first minister, John Joachim Zubly, preached in a brick structure that was used by the British during the American Revolution, but was destroyed by fire in 1790. A decade later a new building was built on what is now Telfair Square. The needs of a growing congregation led to the construction of the current structure on Bull Street.

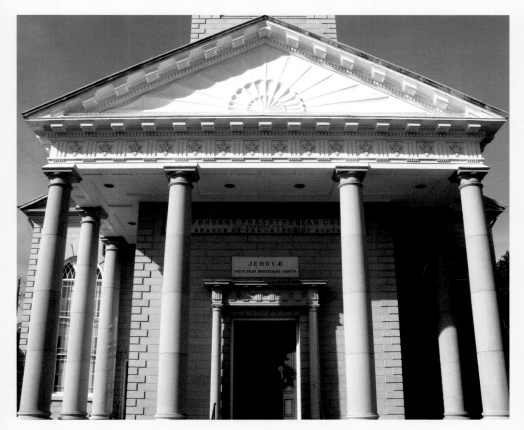

A Christmas wreath gives the entrance to Independent Presbyterian Church a festive appeal. Note the lintel stone is clearly visible over the door.

Architect John Holden Green designed the original Bull Street building. In attendance at the dedication of the new church on May 9, 1819, were President James Monroe and Secretary of War John C. Calhoun.

Lowell Mason served as organist for the next few years. Lowell Mason is noted for being the father of public school music and as the composer of many famous hymns, including: Blest Be the Tie That Binds, O Day of Rest and Gladness, My Faith Looks Up to Thee, and Songs Anew of Honor Framing, as well as many other hymns.

In 1885, future President Woodrow Wilson and Ellen Louise Axson were married in the manse of the Independent Presbyterian Church.

The edifice of 1819 was destroyed in 1889, by a fire that swept through Savannah. Members managed to save a marble baptismal font and flagstones. It was quickly decided to rebuild the sanctuary as it had been. Supervising the rebuilding of the church was William Gibbons Preston, a Boston architect who also designed the Cotton Exchange on Bay Street.

In 1928, the Axson Memorial Building was built on the site of the church manse. This building contains the Mary Telfair Chapel and a reproduction of the manse parlor, the Wilson-Axson room. The Administration Building that was built in 1895 is across the lane from the main church building. The Administration Building houses the church offices, library and a bookshop.

In 1994, the movie *Forrest Gump* (Paramount Pictures) was partly filmed along Bull Street in Savannah. In the opening sequence of the film a feather floats down out of the sky near the steeple and administration building of Independent Presbyterian Church. The Church is clearly visible in the film and it has become a famous location in Savannah for movie buffs.

Notable leaders of Independent Presbyterian Church have included J. J. Zubly, who served from 1758 to 1777. Zubly is noted in American history for his position against the Stamp-Act of 1765. Other notable leaders have included Henry Kollock, who served from 1806 to 1819, and Daniel Baker, who served from 1823 to 1831. Terry L. Johnson has been the pastor since 1987.

A pipe organ has been used to accompany the singing at the church since the dedication of the original building in 1819. The church's first organ was built by William Goodrich of Boston in 1820 and originally played by Lowell Mason. Several replacement organs have subsequently been used. In early 2005, a new Rieger-Kloss organ that originated in the Czech Republic was installed in the sanctuary.

The imposing Mahogany pulpit, left to Independent Presbyterian Church by Mary Telfair in her will with instructions that it be high, remains the focal point of the church's historic sanctuary.

Independent Presbyterian Church, as the name Independent would suggest, is not affiliated with the Presbytery, the governing body of the Presbyterian denomination. Periodically, the flags of the Scottish clans make a brilliant display in the sanctuary, helping members and visitors alike to appreciate the historical tradition of Savannah's Independent Presbyterian Church. This church has continued to have sustained membership over the years, and has seen its grand building appreciated as a staple in the Historic District.

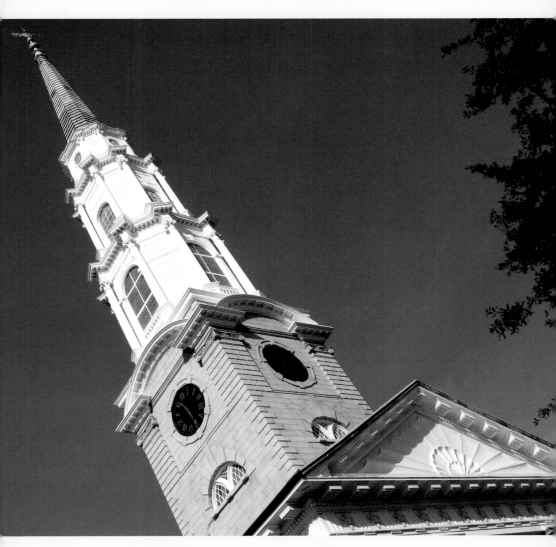

Steeple of Independent Presbyterian. This steeple is the one seen in the opening sequence of the movie *Forrest Gump*.

Isle of Hope United Methodist Church

412 Parkersburg Road

The congregation of Isle of Hope United Methodist Church dates to December 1851. It was originally organized on the mainland and later moved to Isle of Hope. The current site was given as a gift by Dr. Stephen Dupon on June 29, 1859. The pine pews are original to the church.

During the Civil War it was used as a hospital to treat injured soldiers. There were thirty-three young Confederate volunteers from Effingham County who died at the church and were buried in the church yard. A number of Union General Sherman's men used the church as a camp during his time in Savannah. The original bell was melted to make cannon balls.

When the island began to be developed in the 1950s, a full-time minister was called. The sanctuary was moved to its present location in 1957. The wall lamps that are in use today were installed in the late 1950s.

In 1983, a renovation of the sanctuary was started. The planned expansion provided a vestibule and a new front porch. The original pews, chancel rail, lamps, and furniture were removed and stored. The new copper roof and the rest of the reconstruction project were near completion when, on February 22, 1984, the structure burned to the ground. Because many of the church items were in storage at the time of the fire, they were saved. Plans for rebuilding were begun immediately and, due to the generosity of public and private sectors, the new structure was dedicated, free from debt, on February 10, 1985.

By 1998, a new construction project was being planned. The congregation had once again outgrown the sanctuary, so it was expanded with the addition of two side transepts to seamlessly blend in with the existing architecture. The expansion allowed for two hundred additional seats. The sanctuary was also refurbished with new paint and the installation of a new Rodgers organ. The renovation was dedicated in 2000.

After more than 158 years, the Isle of Hope United Methodist Church continues to be a symbol of beauty and inspiration for the entire community.

Isle of Hope United Methodist Church.

Courtyard and bell, Isle of Hope United Methodist Church.

Lutheran Church
of the Ascension

120 Bull Street

The Lutheran Church of the Ascension was founded by German Lutherans in 1741. The church trustees purchased the present lot in 1771. For many years services at the Lutheran Church of the Ascension were conducted in German. Several wooden structures and a single-story brick church preceded the current edifice. The present day sanctuary was constructed in 1843. It was extensively reconfigured in 1878. The next year, in 1879, the church was dedicated and named "The Evangelical Lutheran Church of the Ascension."

In 1966, the U.S. Department of the Interior designated the Lutheran Church of the Ascension as a historical landmark. The Cassavant organ in the balcony was dedicated in 1983.

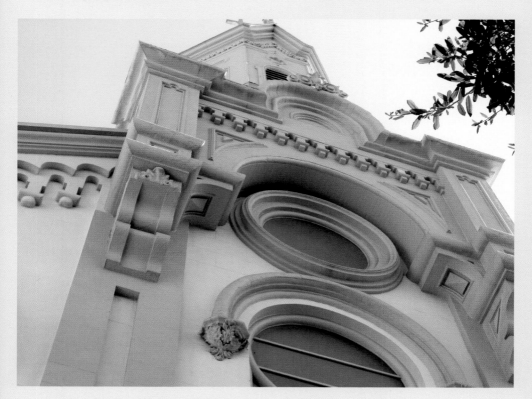

Lutheran Church of the Ascension features some nice architectural details.

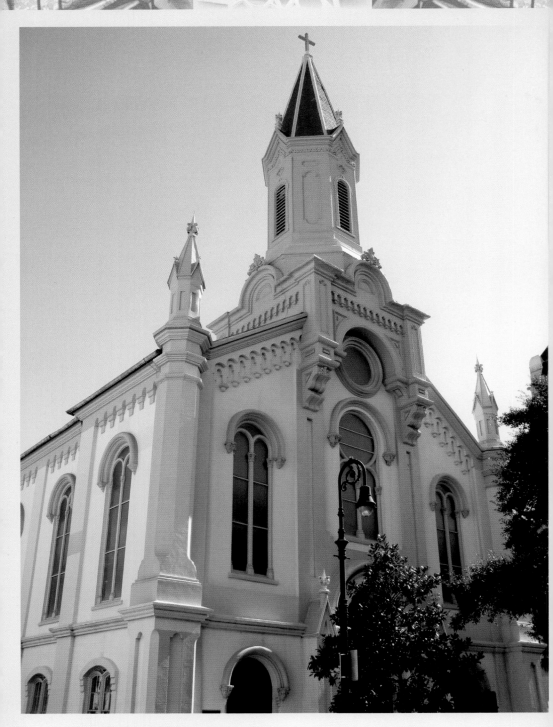

Lutheran Church of the Ascension.

Views of Lutheran Church of the Ascension

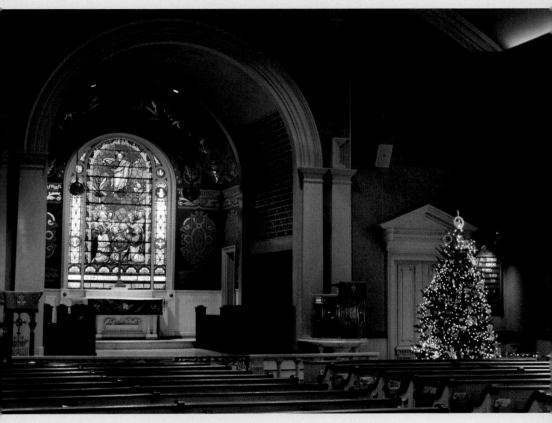

The sanctuary is decorated for Christmas.

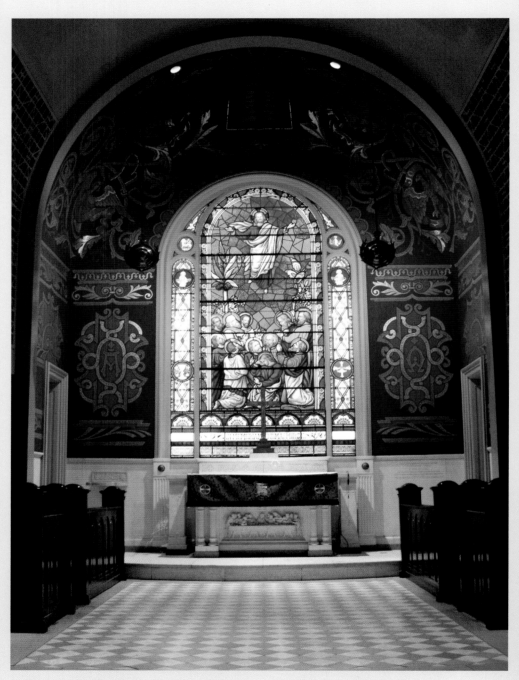

The apse and chancel.

Lanterns give the church
an old-fashion look.

MICKVE ISRAEL

20 East Gordon Street

On July 11, 1733, forty-two Jews arrived in Savannah aboard the ship *William and Sarah*. They had departed London some months earlier with the support of Bevis Marks, London's affluent Sephardic Jewish community. These immigrants were the largest group of Jews to land in North America in colonial days, arriving just five months after General James Edward Oglethorpe established the colony of Georgia. Their main purpose was to establish a Jewish community in the new world.

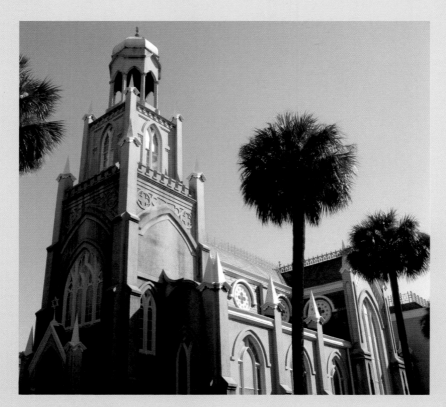

Congregation Mickve Israel.

The founders of Mickve Israel brought with them a "Safertoro" and a circumcision box, which are housed today in the Mickve Israel museum.

Because Georgia had originally been established by Oglethorpe and the trustees as an Anglican utopia, there were some questions about whether the Jews would be allowed to stay. At that time a yellow fever outbreak was ravaging the colony and had killed about ten percent of the colonists, including the doctor. Aboard the *William and Sarah* was Dr. Samuel Nunes Ribiero, who successfully treated many of the colonists during this period. Under his care not a single colonist died. For his services, Oglethorpe granted the Jewish immigrants the right to settle by giving them land for a cemetery. Oglethorpe, at the time, was also fighting the Spaniards in Florida and realized that the mostly Sephardic Jews, ejected from Spain and Portugal during the Spanish Inquisition, would not be sympathetic to the Spaniards.

Also aboard the *William and Sarah* were the Sheftall and the Minis families, who were among the eight Ashkenazi immigrants. In July 1735, they "met together, and agreed to open a Synagogue…which was done immediately, the new synagogue was to be named K. K. Mickva Israel" (Kahal Kodesh Mickva Israel, which is translated as Holy Congregation Hope of Israel).

By 1774 enough Jews were living in Savannah that Benjamin Sheftall reported in his diary, "Having a sufficient number of Jews here to make a congregation we came to a resolution to meet at the house of Mordecai Sheftall which was done." During the Revolutionary War, Mordecai Sheftall became the highest ranking Jewish officer of the American Revolutionary forces, attaining the rank of Deputy Commissary General to the Continental Troops in South Carolina and Georgia.

By the early 1800s the congregation had grown large enough to construct a small wooden Synagogue west of Bull Street. This building, the first Synagogue to be erected in the State of Georgia, was consecrated on July 21, 1820.

The wooden Synagogue was destroyed by fire December 4, 1829, though the Torahs and Ark were saved. A new brick building on the same site was consecrated in 1841.

By 1874, it became apparent that the small synagogue on Liberty Street and Perry Lane was no longer adequate for the growing congregation. On March 1, 1876, the cornerstone was laid for the present Synagogue. The Monterey Square sanctuary was consecrated on April 11, 1878. The new synagogue, designed by architect Henry G. Harrison, was built in a pure neo-Gothic style, which reflected the fashionable architecture of the Victorian era. Mickve Israel is the only Gothic style Synagogue in North America. On the adjacent trust lot stood a neo-Gothic Presbyterian Church until it was destroyed by fire in 1929.

By 1954 the needs of the congregation outgrew the Mordecai Sheftall Memorial Hall. The congregation raised the necessary funds and, on January 11, 1957, the new and enlarged Mordecai Sheftall Memorial Hall was dedicated.

For more than 277 years, Mickve Israel's members have contributed significantly to the larger community. The Honorable Herman Myers was mayor of Savannah from 1895-1897 and 1899-1907. In commerce, law, medicine, the

military, government, politics, and culture the Jews of Savannah have enriched their community and their nation. Some descendants of Mickve Israel's colonial settlers include: Sheftall Sheftall, an early Savannah politician; Mordecai Manuel Noah, sheriff of New York and a founder of the Tammany Hall political machine; Commodore Uriah Phillips Levy, who rescued Monticello from destruction and was responsible for the abolition of flogging in the United States Navy; and Raphael Moses, who planted peach orchards and developed the technology for shipping fruit to far-off markets and may be the father of the peach industry in the "Peach State."

In July 2008, Mickve Israel celebrated its 275th anniversary. Celebrity guest Mandy Patinkin was in attendance at the festivities.

Mickve Israel houses a Jewish museum featuring the original Torah brought over in 1733. This Torah is thought to have been scribed in the 1400s and is believed to be the oldest Torah in North America. Mickve Israel also runs a Hebrew school along with Agudath Achim, the conservative Synagogue in Savannah, and hosts the Jewish Food Festival in Forsyth Park each October.

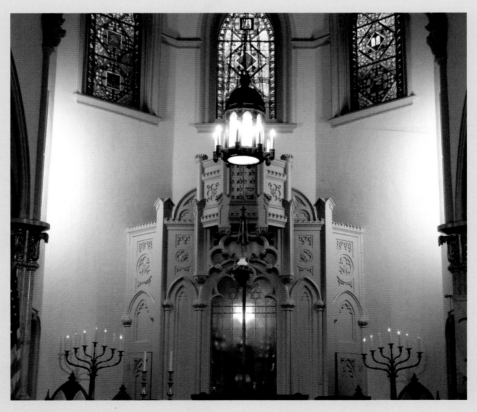

The Ark at Congregation Mickve Israel.

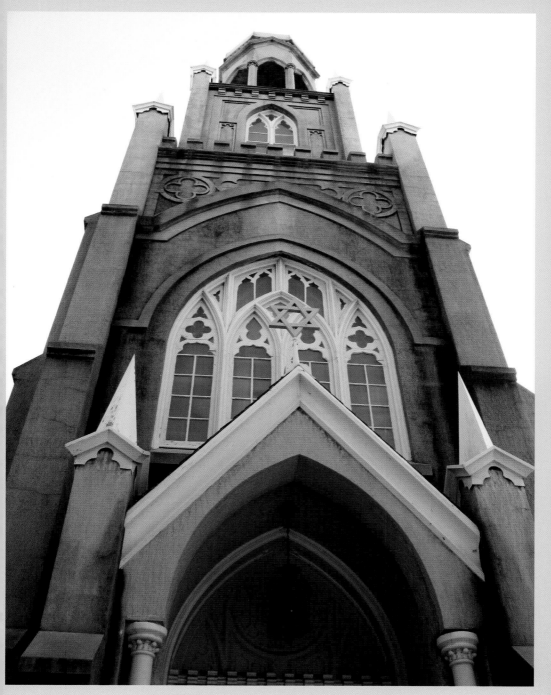

The large spire at Mickve Israel was damaged and repaired after a fire in 1927.

QUAKER
SOCIETY OF FRIENDS

225 West Presidents Street

A loosely organized Quaker congregation has continuously existed in Savannah since the mid-1700s. The congregation has met in several different locations over the years, mostly in the homes of its members. The Savannah Religious (Quaker) Society of Friends now meets at Trinity United Methodist Church on Telfair Square.

The Quaker meeting space at Trinity United Methodist Church.

SACRED HEART CATHOLIC CHURCH

1707 Bull Street

T he parish of Sacred Heart was established by the Benedictines in Savannah's Victorian District in October 1880. A two-story addition was added a year later to accommodate the growing church. There the Sisters of Mercy taught both African American and white students. Father Oswald Moosmueller served as Sacred Heart's first pastor.

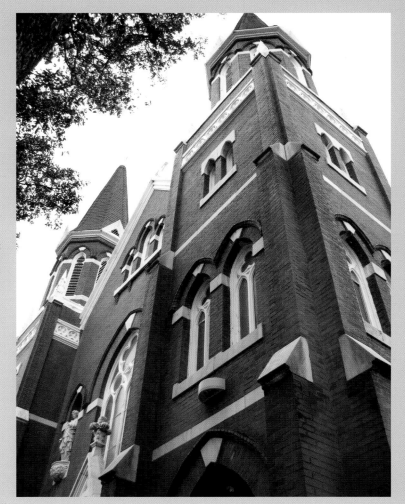

Sacred Heart Catholic Church has a beautiful stone facade.

Views of Sacred Heart Catholic Church

One of the church's entrances.

Sacred Heart Catholic Church has a lot of stone, metal, and wood detailing.

By the turn-of-the-twentieth century, the Sacred Heart parish had grown into a large congregation. The growth spurred the purchase of an entire block of land on Bull Street. The current church cornerstone was installed in December 1902. The supervising architect was Hyman Witcover, who also designed Congregation Bnai Brith Jacob's former synagogue and Savannah's City Hall on Bay Street. Throughout its history Sacred Heart has been closely associated with Mother Mathilda Beasley, Georgia's first African American nun.

The current church on Bull Street is constructed of Philadelphia Red Brick with white Georgia marble trim. Sacred Heart's facade boasts large twin towers that balance the proportions. The architecture of Sacred Heart Catholic Church is classic Gothic Revival. Mounted above the front entrance are twin angel statues that flank the stained glass windows. The parish gymnasium is a multi-use space, being the home of the basketball team as well as a fellowship hall. The Gymnasium is painted blue and white, the team colors. Sacred Heart hosts monthly Contra dances in the gymnasium that are put on by the Savannah Folk Music Society.

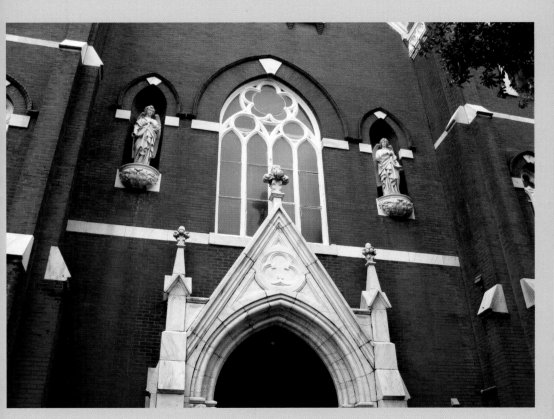

Statues over the entrance along Bull Street.

The sanctuary contains large stained glass windows that behold various icons from the Catholic tradition. The stained glass windows were designed and built in Munich, Germany. The sanctuary contains an arched, vaulted ceiling that stretches from wall-to-wall. Oak pews, wainscoting, and narrow board flooring complement the nave's marble trim. Much of the flooring throughout the sanctuary is marble. The high marble altar was installed during the 1973 renovation. Sacred Heart Catholic Church has a large pipe organ that faces the altar. The organ is located in the balcony above the front entrance and looks out over the congregation.

Architectural detail on the roof.

SECOND AFRICAN BAPTIST CHURCH

123 Houston Street

T he history of Second African Baptist Church begins in 1802, when Deacon Henry Francis and Henry Cunningham were ordained as ministers. The Reverend Henry Cunningham received his letter from the white Savannah Baptist Church. Upon ordination, the newly formed congregation chose a location for their new church.

The church building, located on Greene Square, was described as a comfortable building, 67 x 30 feet. It was completed in December 1802 and officially established as the Second Colored Baptist Church. Records indicate some of the founding members were Richard Houston, Susan Jackson, Charlotte Walls, Leah Simpson, and Elizabeth Cunningham.

Second African Baptist Church.

With a new church building and a senior minister, Second Colored Baptist became a place of community. Second Colored Baptist trained more black preachers than any other Baptist Church in the country. By the year 1848, Second African Baptist Church had trained five of the six pastors at First African Baptist Church.

Reverend Cunningham was the senior pastor at Second Colored Baptist Church from 1802 to 1808 and then again from 1813 until his death, March 29, 1842. Prior to 1833 the name Second Colored Baptist Church was changed to Second African Baptist Church. In 1833, the name of Second African Baptist Church was changed by the congregation to Second Baptist Church. Many members were baptized in the Savannah River because they did not have baptismal facilities. Under the early leadership of Reverend Cunningham church membership grew to around 1500 by 1840. Reverend John Cox was called to be the pastor of the church in late 1848.

The church stayed open during the years of the Civil War. In December of 1864, Second Baptist Church was host to Secretary of War Edwin M. Stanton and General William T. Sherman. A large audience attended Second Baptist Church for this historical event. During this event Gen. Sherman read The Emancipation Proclamation to the audience and made his now famous Forty Acres and a Mule Speech. This speech guaranteed all freed slaves land of their own and a mule to work the fields.

Reverend John Cox served until his passing in 1870. In 1892, the Reverend J. J. Durham was called. Dr. Durham was a preacher, medical doctor, blacksmith, and botanist. In 1889, the congregation pooled their resources and elevated the church nineteen feet, more than doubling their previous space. It featured a stone foundation with a wooden upper story, leaded, stained-glass windows, chandeliers, and cushioned pews. Reverse back benches were also made for the fellowship hall. It was during Dr. Durham's tenure that Second Baptist Church celebrated its 100th Anniversary in December 1902.

In the early 1940s, the Monroe family presented Second Baptist Church with their first pipe organ. It was during these years that the church edifice was restored following one of Savannah's many fires.

During the Civil Rights years, Second African Baptist peacefully went about serving Savannah. In the early 1960s, Dr. Martin Luther King, Jr. preached his "I Have a Dream" sermon from the pulpit of Second African Baptist Church.

In 1985, the congregation decided to change the name of the church from Second Baptist Church back to Second African Baptist Church. The history of Second African Baptist Church continued with the publication of a church directory, a new organ and various remodeling projects. In these years, the membership continued to increase.

In November 1998, Second African Baptist Church called the Reverend C. MeGill Brown as its twenty-first, and current, pastor. In 1999, the congregation began a major renovation project that included the installation of an elevator, a new outside sign, and restoration of the main sanctuary and exterior of the church. In 2002, the church celebrated its Bicentennial with many activities highlighting the theme: "1802-2002: 200 Years of Service."

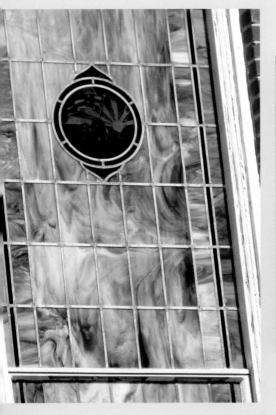

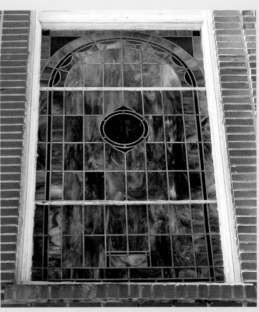

Stained glass detail.

In December 2004, Reverend Brown and his wife became the proud parents of a baby boy. It is believed that he is the first pastor to have a newborn while in service at the church.

Second African Baptist Church continues its proud history, as it serves Greene Square and all of Savannah. The church is open for guided tours with a reservation.

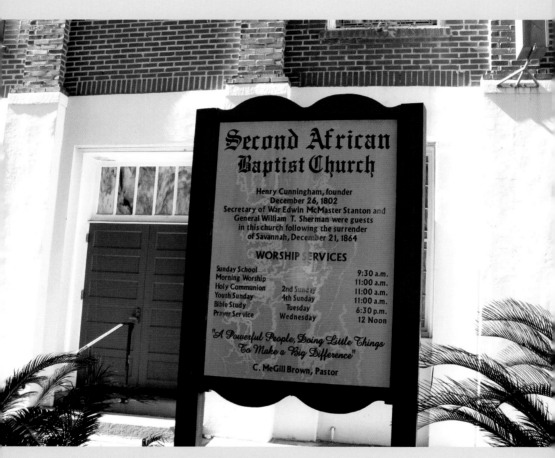

Historical marker and schedule sign outside Second African Baptist. This marker is facing east onto Greene Square.

St. Benedict the Moor Catholic Church

556 East Gordon Street

The history of St. Benedict the Moor Catholic Church began May 13, 1874. In that year, two Benedictines, Fr. Bergier and Fr. Wissel, arrived in Savannah to serve the Catholic African American community. Later that year, they built and dedicated a small wooden church on the corner of East Broad and Harris Streets. The new church was built in only two weeks. The site of the original church is four blocks north of the present church.

A yellow fever epidemic hit Savannah in 1876, and took the life of Fr. Bergier. In 1888, the Bishop purchased land and a new church was constructed the following year. Fr. Ignatius Lissner and Fr. Gustave Obrecht came to serve St. Benedict the Moor in 1907. St. Benedict the Moor soon became the "Mother Church" for black Catholics in Savannah and the surrounding area. Fr. Obrecht served as pastor for over thirty-eight years. Four years after Fr. Obrecht's service the church leaders decided to construct a new building. The current brick church building that stands on Broad Street was completed in 1949, with only minor renovations since that time.

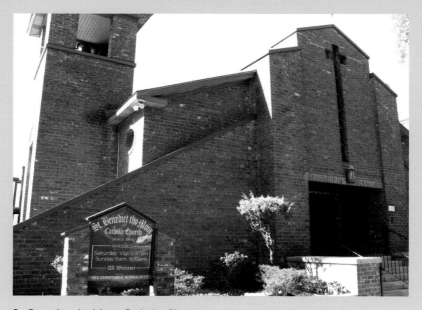

St. Benedict the Moor Catholic Church.

The Franciscan Sisters have a special place in the history of the parish. The Sisters served the school at St. Benedict for seventy years, from its beginning around 1900 until its closure around 1970. Along with the school, the Franciscan Sisters also staffed the orphanage that was started by Mother Mathilda Beasley, the first black nun in Georgia.

In the new century, the Missionaries of St. Paul of Nigeria were given charge of the parish, with Fr. Desmond C. Ohankwere named pastor. In 2003, the church held meetings to determine the churches direction for the next half decade. The parish wanted to continue to be a "beacon of light" in the community and continue the history of the congregation. The parish wanted to provide and support programs for children, teenagers and seniors in the community. Because there was no space

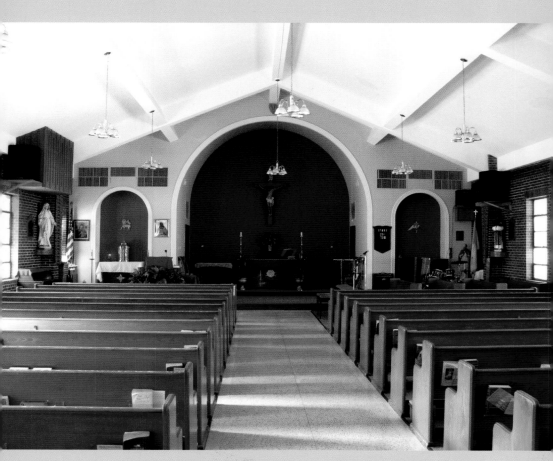

The sanctuary of St. Benedict the Moor Catholic.

available to provide these services, the church leaders decided to restore the old school building that had been vacant for many years.

A fund-raising campaign was developed for the remodeling of the structure and again to provide the opportunity for this building to be used by the church and the community. In October 2007, this restoration was started. On January 3, 2008, Fr. Christian Anosike Alimaji became the religious leader of St. Benedict the Moor Church.

In recognition of St. Benedict the Moor's rich history as the oldest African American Catholic church in the State of Georgia, the Georgia Historical Society presented the church with an Historical Marker on June 13, 2008. Later, on October 16th, the church had an unveiling ceremony for the marker.

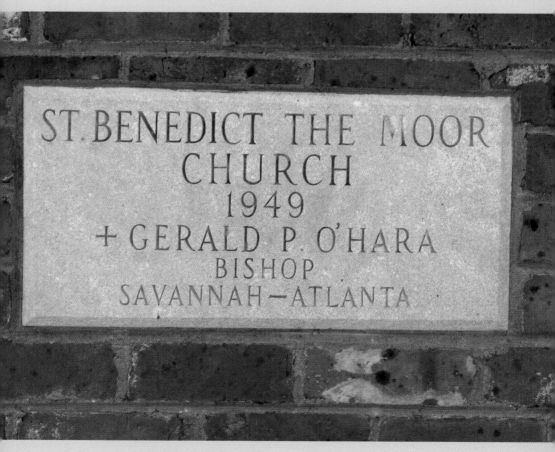

Cornerstone from 1949, St. Benedict the Moor.

St. John's Episcopal Church

1 West Macon Street

St. John's Episcopal Church was built in 1853, on the newly developed Madison Square. The church was designed by architect Calvin Otis, of Buffalo, New York. The sanctuary is very ornate and contains some of the most outstanding woodwork in Savannah. The alter area, pews and vestibule are all made of hand carved wood detailing, most of which is original. Gold trim compliments the woodwork. It has many picturesque stained-glass windows depicting scenes from the Christian tradition. A ship's mast is located in the center of St. John's only spire, no reasonable explanation for the mast can be found. The church is simple in its exterior design, having the look of a British parish house. Large Indian Hawthorn shrubs compliment the taupe stucco along the buildings southern side. A central courtyard garden is located in what used to be the lane separating the church from The Green-Meldrim House. The church today hosts many events and lectures.

The Green-Meldrim House, which is now the parish house for St. John's Episcopal Church, was built in 1850 for a wealthy cotton merchant named Charles Green. He had it built as a showcase home. It was designed by the famous architect, John Norris, who also designed the Customs House on Bay Street. The Green-Meldrim House, a classic example of Neo-Gothic Revival architecture, is located on the adjacent trust lot, next to St. John's Episcopal Church.

On December 24, 1864, near the end of the Civil War, General William Tecumseh Sherman arrived in Savannah after burning Atlanta and Macon, Georgia. Upon his arrival, Savannah surrendered the city to General Sherman. Charles Green then offered his house to General Sherman and his Union officers. Due to Green's hospitality, General Sherman spared the City of Savannah from almost certain destruction. In his bedroom at the Green-Meldrim House, General Sherman wrote a famous telegram to President Abraham Lincoln. In the telegram, General Sherman offered Savannah and 25,000 bales of its cotton to the President as a Christmas present. General Sherman and the Union officers occupied the Green-Meldrim House until April 1865.

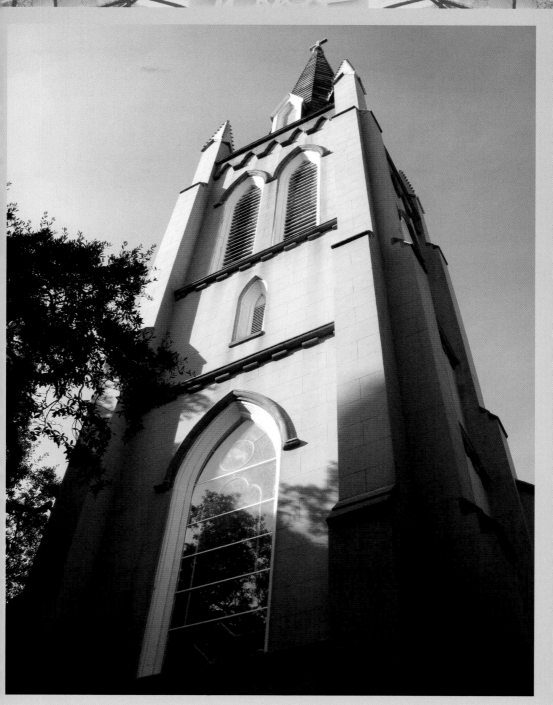

St. John's Episcopal Church.

The mansion was owned by the Green and the Meldrim families before it was sold to St. John's Episcopal Church in 1943. The church rectory is now housed in what was the servants' quarters, kitchen and stables.

The Green-Meldrim House was recently used as a set for the Robert Redford film, *The Conspirator* (The American Film Company). The house's two parlors, magnificent hallway, and grand staircase were used for a large Union victory party scene. The film, about the conspiracy to assassinate Lincoln, was filmed in Savannah from October to December 2009.

The Green-Meldrim House is open to the public for guided tours.

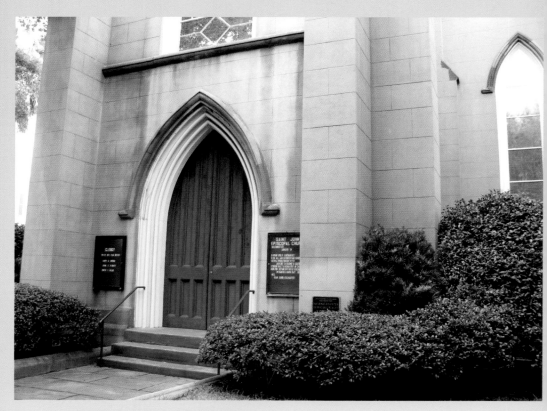

Entrance, St. John's Episcopal Church.

Views of St. John's Episcopal Church

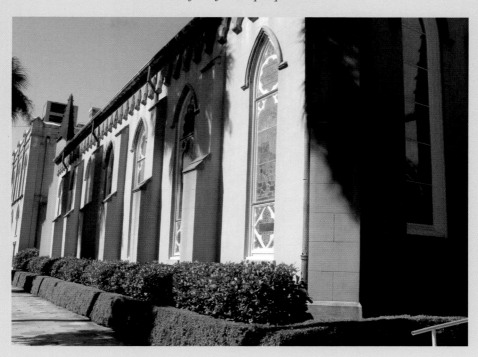

Row of stained glass windows.

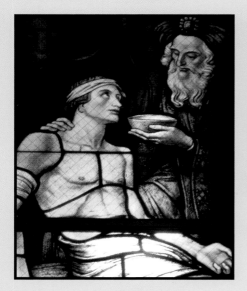

Courtyard garden. The garden of St. John's Episcopal was featured on the cover of the author's book *Savannah's Garden Plants*.

Stained glass window detail.

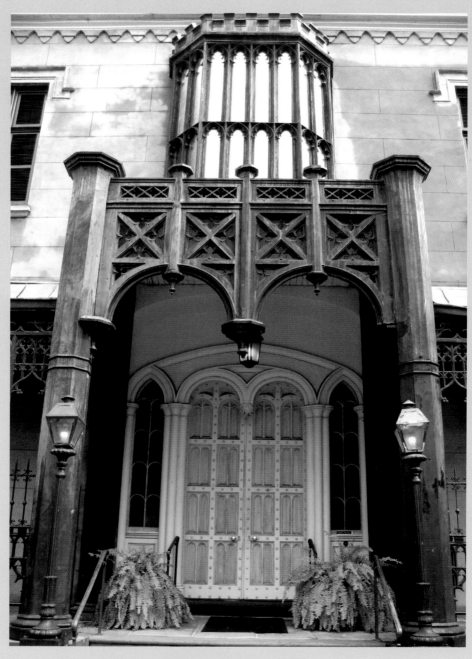

Grand entrance to the Green-Meldrim House, which is the parish house for St. John's Episcopal. The Green-Meldrim House was featured in Robert Redford's movie *The Conspirator*.

St. Paul's Evangelical Lutheran Church

10 West 31st Street

S t. Paul's Evangelical Lutheran Church is a satellite of the Lutheran Church of the Ascension on Wright Square. St. Paul's was started as a mission Sunday school in 1884 or 1885 by the wife of Pastor Bowman of the Lutheran Church of the Ascension.

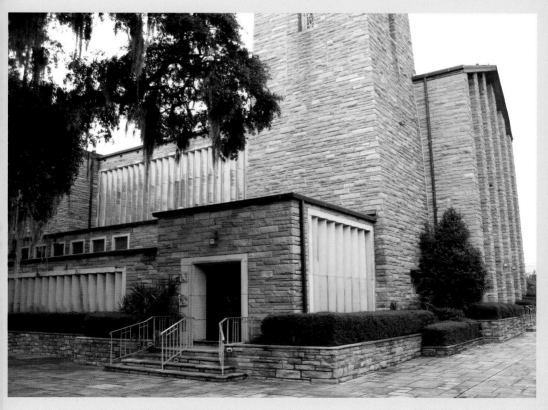

St. Paul's Evangelical Lutheran Church.

By September 1889, the class had grown large enough to be organized into a Mission Sunday School sponsored by the Sunday School Teachers Association and was renamed St. Paul's Lutheran Mission Sunday School. Over the next several years, the class continued to be well-attended and by 1894 the Rev. M. J. Epting was called from St. Luke's Lutheran Church in South Carolina to be Assistant Pastor of the Ascension Church with the purpose of developing the Sunday school class into a congregation. The new congregation of 148 members was established November 3, 1895. Rev. Dr. Epting remained pastor until his death on July 14, 1927.

St. Paul's continued to prosper into the new century. By 1956, growth of the Church led to talk of a new building. Money was raised and the building was built. The new building was complete by 1957, and on Palm Sunday the new sanctuary was dedicated. In the fall of 1957 an Aeolian-Skinner organ was installed. The 1957 organ continues to be used today.

St. Paul's Evangelical Lutheran Church steeple. The stained glass panels at the top of the steeple are often lit at night.

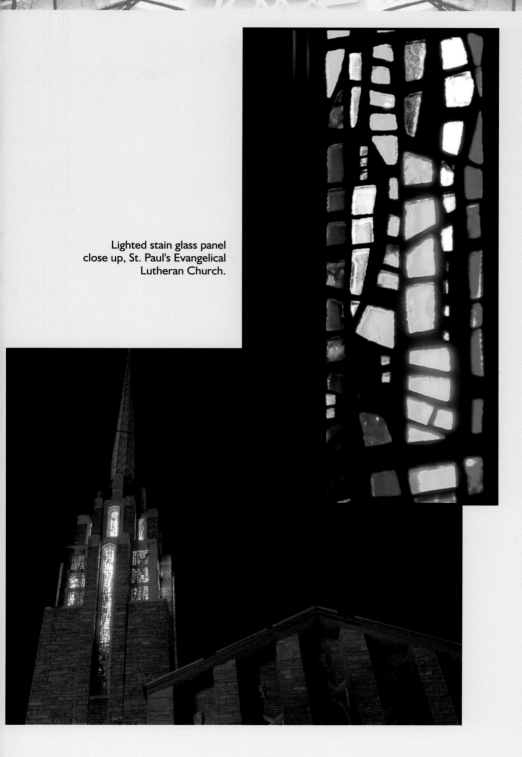

Lighted stain glass panel
close up, St. Paul's Evangelical
Lutheran Church.

St. Paul's Greek Orthodox Church

14 West Anderson Street

The Greek Orthodox Church in Savannah was organized in 1900 and received its charter in 1907. In that year a church building was purchased from St. Paul's Episcopal Church on the corner of Duffy and Barnard streets for the one hundred original founders of the congregation. The new congregation decided to keep the name St. Paul's and continued conducting services under the name St. Paul's Greek Orthodox Church.

Between the years 1928 and 1937, the Greek Orthodox congregation had many firsts. In the late 1920s, the first Sunday school for children was established. The first gender mixed choir was organized in 1930. The Cantor was replaced with choral singing from male and female voices during regular services. This tradition continues today.

On August 25, 1941, St. Paul's Parish purchased the Lawton Memorial Building from the City of Savannah. The Lawton Memorial Building was constructed on the corner of Bull and Anderson Streets in 1897-98 as a memorial to Gen. Alexander Robert Lawton, who lived from 1808 to 1896. The Lawton Memorial Building was used as a public auditorium for civic purposes until the 1930s. A two-year renovation project was undertaken to transform the structure into the church's current house of worship. In the sanctuary are beautifully hand painted Icons from the Greek Orthodox tradition. The ceiling boasts nine individual Icons, as well as a magnificent chandelier that illuminates the space. The chandelier, made in gold filigree, depicts a winged creature, grapes on the vine, and several portraits. The sanctuary also has some of the most intricate woodwork in the City of Savannah. Clear glass paneling separates the sanctuary from the vestibule. The building is a Greek Revival style architectural landmark.

On May 9, 1943, the new church was dedicated with Bishop Gerasimos officiating. Fr. John Hondras was among the first graduates of the first Greek Orthodox Seminary in the United States when he came to St. Paul's in 1943.

The Hellenic Center opened May 21, 1951. In the Greek Orthodox tradition, a Hellenic Center acts as a fellowship hall. A celebration honoring the 50th Anniversary of St. Paul's Parish capped 1957. In 1958, the building behind the church was purchased and used for a Sunday school annex. This acquisition gave the church needed space for its growing Sunday school program.

Fr. Thomas Paris succeeded Fr. Dennis Latto as leader of the community in 1962. The next year, in 1963, the growing parish purchased the five remaining buildings behind the Church. The entire block at Bull and Anderson Streets became the church campus.

During the 1970s, the City of Savannah elected the Honorable John Rousakis its first Greek Mayor. Rousakis Plaza, a public park along River Street, was built in 1979 and named for Mayor Rousakis.

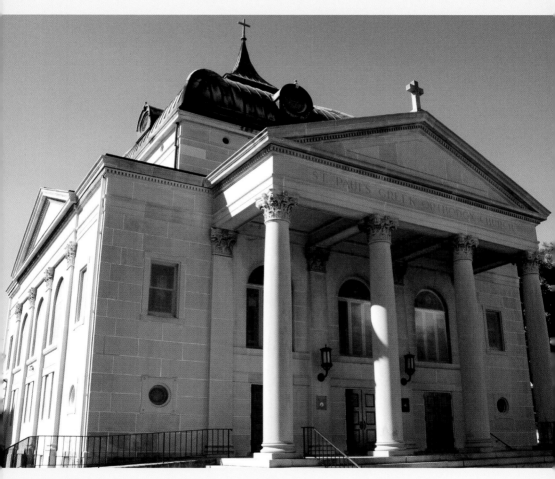

St. Paul's Greek Orthodox Church.

In 1982, the 75th anniversary was acknowledged with much celebration and social festivity. In 1985, progress continued in the Parish. This year also marked the beginning of the "Savannah Greek Festival." This festival celebrates Greek culture, heritage and hospitality. Visitors may enjoy a guided tour of the sanctuary and hear the story of the Greek Orthodox tradition. Greek food and music are shared with the people of Savannah and the world.

Throughout the 1980s and early 90s, St. Paul's had several leaders. In the mid-1990s, a fund-raiser was initiated by the church for a renovation project. In 1998, the plans to redesign and change the interior and exterior began. In January 2000, St. Paul's began to implement the renovation project. Work was carried out to repair and update the entire church.

On May 22, 2001, the Georgia Historical Society dedicated a historical marker to General Alexander Lawton and St. Paul's Greek Orthodox Church. The marker now stands outside the church to tell visitors the story of St. Paul's Church building. Early 2001 marked the completion of the renovation of the church. On June 29 and 30, 2001, the church was rededicated by His Grace Alexios, Bishop of Atlanta. In July 2002, Fr. Soterios Rousakis succeeded Fr. Nicholas Capilos. Fr. Rousakis remained as Parish Priest until July 2004. Fr. Vasile Mihai came to serve at St. Paul's from Greensboro, North Carolina.

St. Paul's Greek Orthodox Church is one of the youngest of Savannah's historical churches. Although its history only reaches back just over one hundred years, it has established its place in the community. The future looks bright for this active and committed congregation.

Views of St. Paul's Greek Orthodox Church

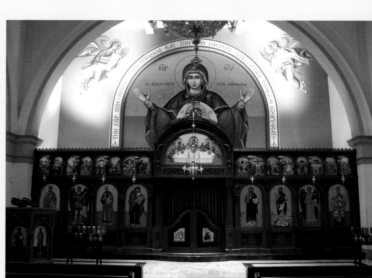

The sanctuary.

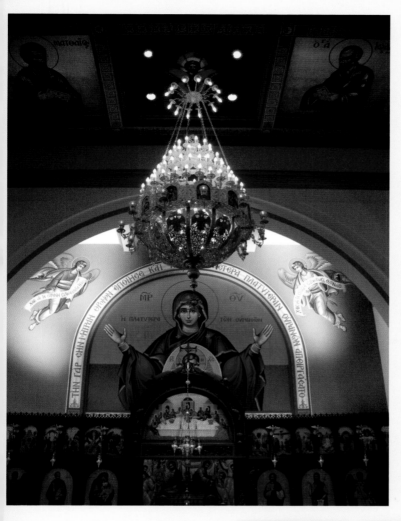

Detail of the alcove
and chandelier.

Icons on the sanctuary ceiling.

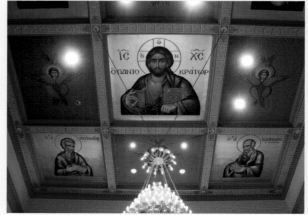

St. Philip African Methodist Episcopal

613 Martin Luther King Boulevard

St. Philip African Methodist Episcopal is the first and oldest African Methodist Episcopal Church in the state of Georgia. It was organized by the Rev. A. L. Stanford on June 16, 1865.

In 1887, the Rev. J. B. Lofton was selected as minister and he served until 1891. Under his leadership the construction on the church was completed and all debts were settled.

Rev. L. H. Smith served from 1895 to 1899. It was during the tenure of Rev. Smith that the church was destroyed by the storm of 1896. It was at this time that the congregation voted to change locations. Following Rev. Smith, the church appointed Rev. C. C. Cargile, under whose administration the church flourished and was again cleared of debt brought on by the new building. In December 1909, Rev. Singleton became the pastor and served seven years, the first minister to serve more than four years. Over the next few years the present modern brick structure was completed. The new church was unique because it was designed by an African American architect, J. A. Langford. The building was designed in a Romanesque Revival style which is a Greek and Roman structure.

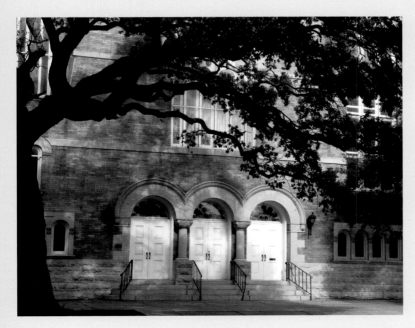

St. Philip African Methodist Episcopal. A Live Oak graces the magnificent entrance along the MLK Boulevard.

St. Philip African Methodist Episcopal **113**

In the 1920s and 30s several pastors filled the pulpit. Rev. Dinkins is referred to as the "Hero Pastor," and during his tenure the church was put up for sale due to a debt, the north wall collapsed and the boiler exploded. St. Philip African Methodist Episcopal survived and continued.

In the 1940s the church installed a new Austin Pipe Organ. In 1964, a new parsonage was built, and additional renovations were done in the Sunday school section as well as the main sanctuary under the leadership of Dr. Benjamin Gay. Dr. Gay, at eighteen years, was the longest serving minister in the history of St. Philip African Methodist Episcopal. In 1982, the building and main sanctuary were both remodeled.

A new Van Zoren Organ console was purchased, installed, and dedicated Sunday, April 13, 1986. In 2000, St. Philip converted the parsonage adjoining the church into a full-service childcare center. As the history of St. Philip moves into the new century, the church continues to serve the west side of Savannah.

The steeple of St. Philip African Methodist Episcopal.

TRINITY UNITED METHODIST CHURCH

225 West Presidents Street

The congregation that became Trinity United Methodist Church had its beginnings as Wesley Chapel. The church was formed in 1812 and led by the Reverend James Russell. The Wesley Chapel congregation built a two-story wood frame church at the corner of Lincoln Street and East Oglethorpe Avenue. The logs that were used in the construction of the church were cut from the surrounding Pine forest and were floated down the Savannah River to their final location by Reverend Russell himself. The pastor went into personal debt to see the completion of America's first Methodist church. Bishop Francis Asbury dedicated and preached in this building. There were originally twenty-seven white members and twenty-five black members. Wesley Chapel became the founding churches for both Trinity United Methodist Church and Asbury Methodist Church.

Trinity United Methodist Church as it looks today.

As Wesley Chapel grew, a larger church building became necessary and a new location was discussed. The south west trust lot on Telfair Square was selected. The new location had been the site of the Telfair family garden, and was purchased for $8,500. In the mid-1800s, this purchase price was an enormous sum. The cornerstone of Trinity United Methodist Church was laid on February 14, 1848.

The church was designed by famous South Carolina architect John B. Hogg. The sanctuary, built in a pure Corinthian architectural style, and an educational building were built for $20,000. The walls are made of Savannah Grey Brick and finished with stucco. Savannah Grey Brick is a historically significant construction material, made from the native soil and local to coastal Georgia. The woodwork is made of virgin long leaf Georgia pine. The frame, flooring and wainscoting were all hand hewn and finished. The boards were cut to the taper of the tree and fitted together. The new church was completed in the fall of 1850. Upon completion of the new church, the name was changed from Wesley Chapel to Trinity Methodist Church.

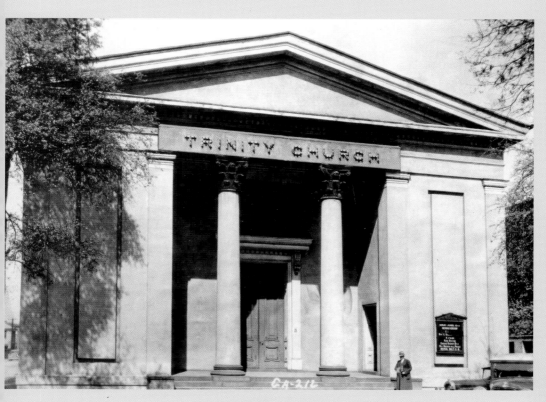

Historical photograph of Trinity United Methodist Church, circa 1930.

Contrary to rumor, John Wesley never preached at Wesley Chapel or at Trinity United Methodist Church. John Wesley returned to England in 1738, and never sailed to America again. He died in his native country in 1791, twenty-one years before Wesley Chapel was formed.

The ornate marble baptismal font was a gift from the Independent Presbyterian Church in 1889. The educational building is named for long time church member Robert McIntire (B. 1817, D.1895). Mr. McIntire was a local grocer. Twice, as a result of his store's alcohol sales, members of Trinity tried to have Mr. McIntire's church membership revoked. Twice he promised to stop selling alcohol and made a donation. Upon his death, Mr. McIntire left his fortune to Trinity Methodist. A large portion of the money was used to further Wesley Monumental United Methodist Church, as well as several other churches. The Robert McIntire Educational Building was completed in 1927, and rebuilt after the great fire of 1991. The sanctuary was largely unharmed during the fire, with most of the damage contained in the Robert McIntire Educational Building behind the sanctuary. The congregation was out of the church for over two years as a result of the fire. It was reported that one man died of a heart attack while fighting the fire.

Views of Trinity United Methodist Church

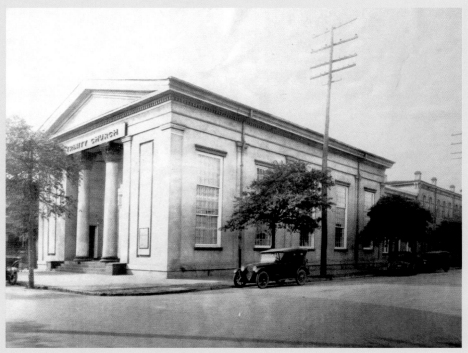

This historical photograph and the one seen on page 115 were not taken at the same time. They both feature the light bulb marquee, but the schedule sign and trees are different.

The Moller organ was installed in 1949, and has a total of 2,280 pipes. It contains both manual and electronic components. In 2010, the organ was refurbished to its original condition for a cost of $600,000. Reverend Enoch Hendry, the current pastor, was instrumental in raising the funds and getting the pipe organ project completed.

Trinity United Methodist Church hosts the Savannah Book Festival, an annual event held in February. In addition, to the Savannah Book Festival, the church also holds lectures and book signings throughout the year.

Today, Trinity United Methodist Church is known for being the oldest Methodist church in America and is often referred to as "The Mother Church of Methodism."

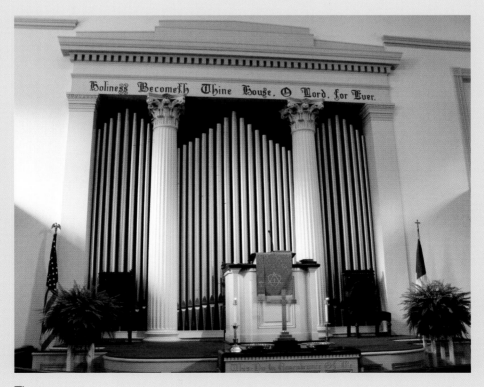

The sanctuary.

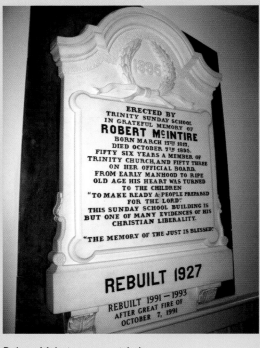

Robert McIntire memorial plaque.

After one of the fires at Trinity, Independent Presbyterian Church presented this baptismal font to the church for the recovery effort.

Baptismal font component.

The entrance to the church.

WESLEY MONUMENTAL UNITED METHODIST CHURCH

429 Abercorn Street

America's first Methodist Church was established in 1807 and was located at the corner of Lincoln Street and Oglethorpe Avenue in Savannah. The congregation later obtained a lot on Telfair Square at the site of the former Telfair family garden. The present day Trinity United Methodist church was built in 1848.

The Reverend A. M. Wynn was serving as pastor of Trinity Church when, in 1866, plans were formulated to establish a city mission. This was done with services of the new mission being held in the Chatham Academy building until early 1868. On January 19, 1868 Wesley Church was organized to replace City Mission that had fifty-four members at that time.

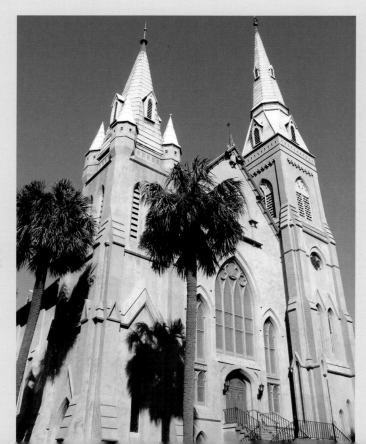

Wesley Monumental
United Methodist
Church.

Trinity Church also owned the trust lot facing Calhoun Square, and in 1874 plans were being made for the erection of a new church building on that lot. It was to be a monument to John and Charles Wesley. John Wesley is the founder of Methodism.

Construction on the new Wesley Monumental Methodist Church began June 30, 1875. Work was slow due to financial difficulties after the Civil War. It took the church until May 1878 to be able to use the first floor. It took twelve more years before the sanctuary on the second floor was finished and dedicated on May 30, 1890. The steeples and the stucco were not in place at that time.

The church architecture is patterned after Queen's Kirk in Amsterdam, The Netherlands. It is in the Gothic architectural style with spires measuring 136 and 196 feet in height. The sanctuary boasts several magnificent stained glass windows that were imported from Europe. The height of the sanctuary from floor to ceiling is forty-three feet. In 1902, a steel ceiling was installed in the sanctuary enabling it to survive two subsequent fires.

The dedication ceremony for the new educational building was held on February 20, 1927. Also in 1927, the outside steps and door leading to the sanctuary were added.

Views of Wesley Monumental United Methodist Church

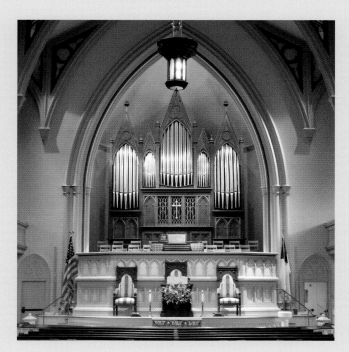

The sanctuary.

In 1963, Mrs. Samuel Rotan offered a 130-acre estate located on Burnside Island as a gift to the church. It was originally known as Folly Marsh, but was renamed Wesley Gardens by Mrs. Albert Trulock. It has been used by the church since that time. The Wesley Gardens retreat center hosts many church and community events. In 2010, Wesley Gardens hosted a lecture/concert by Don Saliers and his daughter Emily Saliers. Don Saliers is a well-known hymn arranger and Emily Saliers is half of the folk rock duo The Indigo Girls.

The Noack organ, designed and built by Fritz Noack of the Noack Company of Massachusetts, was dedicated February 19, 1985. The Gothic style of the organ case is compatible with the architectural style of the church building.

As of 2010, Wesley Monumental United Methodist Church has been remodeling the exterior of the building, closing a doorway and installing a reproduction historic window to match the existing windows. The church has also been restoring the Espy House building on the adjacent trust lot to use as office, classroom and garden space. Wesley Monumental United Methodist Church has been serving Calhoun Ward and Savannah for over 120 years.

Stained glass of John and Charles Wesley, the founders of the Methodist religion.

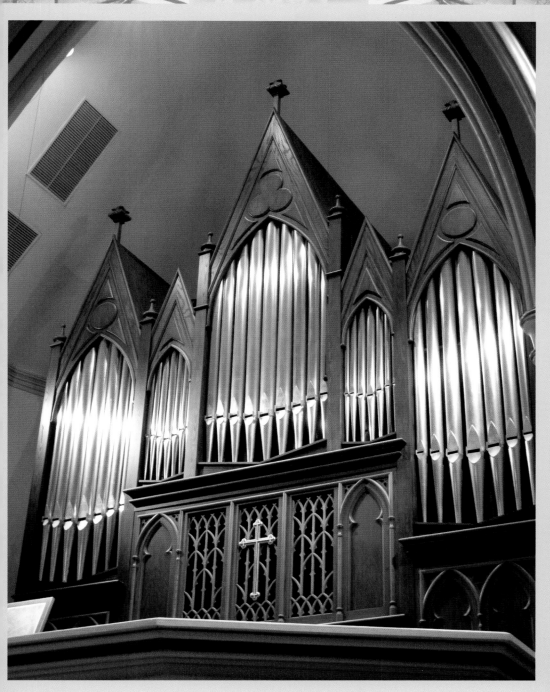

The church organ.

The gardens of the Espy House. This garden was designed, installed, and is maintained by George Wilson.

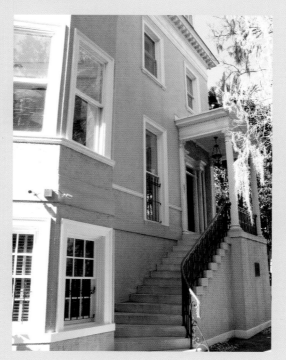

The Espy House entrance. The Espy House was recently used as a set location for the Robert Redford film *The Conspirator*.

WESLEY OAK UNITED METHODIST CHURCH

3124 East Victory Drive

T he congregation of Wesley Oak was formed in 1910. The present church building was built in 1913. Wesley Oak was named after a Live Oak tree that John Wesley preached under in the early 1700s.

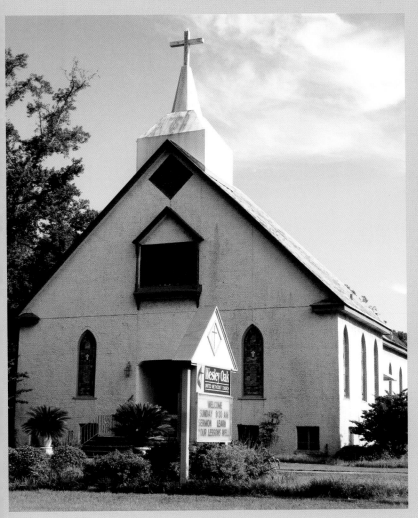

Wesley Oak United Methodist Church.

WHITE BLUFF
PRESBYTERIAN CHURCH

10710 White Bluff Road

The history of White Bluff Presbyterian Church dates to 1737, when 160 Germans came to Georgia as indentured servants. Soon after completing their terms of service, each received land grants of fifty acres.

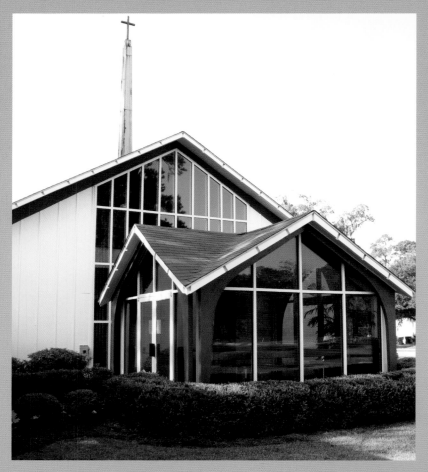

White Bluff Presbyterian Church.

Upon hearing John Joachim Zubly preach in February 1745, the German settlers petitioned the trustees, asking for Zubly as pastor. They also requested land on which to build a meeting house. The first pastor, J. J. Zubly, was involved in the Georgia Colonial Assembly and the Second Continental Congress. In August 1745, the congregation received two acres of land. These two acres are where the current church stands today. The congregation also received an amount "not to exceed 40 schillings" for their meeting house. This church was called White Bluff Meeting House for two centuries. The property was deeded to the congregation by King George II in 1759.

Historians believe the congregations' first three buildings were small, frame structures. During the Civil war, White Bluff Meeting House was abandoned. It was damaged by Union troops, but repaired.

Historic cemetery at White Bluff Presbyterian Church.

The church was destroyed by fire in 1889. The White Bluff congregation erected a new frame building on the same site in 1895. The new frame structure stood until 1962, when it was moved to the back of the property. In 1963, White Bluff Presbyterian Church was burned by vandals.

While little remains from the early history of the church, a cemetery still exists at the back of the church grounds. The earliest grave markers would have been made of wood and have been gone for years. The grave stones that can be found in the church's historic cemetery date from the early 1800s. For many years Sunday school was the only weekly service, because the small congregation was not able to afford a full time leader. The old church bell does remain and is on display in the church's courtyard.

Records found from 1848 state that services were held outside "while men rubbed down the horses and children hunted for Hickory nuts." Later, the men gathered around until the final ringing of the bell called them in together. The choir consisted of six stouthearted laborers crowded into one pew and sang with a conviction that made up for any lack of musical prowess.

Although long considered a community church, White Bluff was supplied with pastors who were trained in the Presbyterian tradition. In 1945, White Bluff officially became part of the Presbyterian Church. Today, the congregation gathers in a modern brick sanctuary. The church also has a social hall and an education building. White Bluff Presbyterian Church is located in a neighborhood called Southside, about nine miles from the Historic District. The Reverend Eric Beene has served White Bluff Presbyterian Church since 2006.